# MINOLTA
# 7000

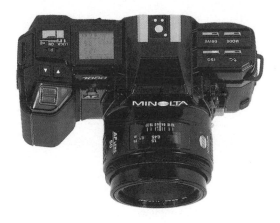

Herbert Kaspar

**AN ORIGINAL**
**HOVE FOTO BOOKS**

## In U.S.A. and Canada
the Minolta 7000 is known as the
# MAXXUM 7000
All text, illustrations and data apply to cameras with either name

MINOLTA 7000
First English Edition May 1986
Second English Edition March 1988
Reprinted June 1990
Reprinted February 1995
Published by Hove Books Limited
Hotel de France, St Saviour's Road
St Helier, Jersey, Channel Islands JE2 7LA
Tel: (01534) 614700  Fax: (01534) 887342
Printed by
The Guernsey Press Co Ltd, Commercial Printing Division
Guernsey, Channel Islands

British Library Cataloguing-in-Publication Data
A catalogue record for this book is available from the British Library

ISBN 0-86343-165-8

Worldwide Distribution

Newpro (UK) Ltd
Old Sawmills Road
Faringdon, Oxon,
SN7 7DS, England
Tel: (01367) 242411  Fax: (01367) 241124

This publication is not sponsored in any way by Minolta Camera Co. Ltd. Information, data and
procedures in this book are correct to the best of the author's and publisher's knowledge.
Because use of this information is beyond the author's and publisher's control, all liability is
expressly disclaimed. Specifications, model numbers and operating procedures may be
changed by the manufacturer at any time and may, therefore, not always agree with the
content of this book.

# CONTENTS

Foreword . . . . . . . . . . . . . . . . . . . . . . . . . . . . . . . . . 9
The Birth of a Family . . . . . . . . . . . . . . . . . . . . . . . 11
A Few Words on the Subject of Focusing . . . . . . . . . . . 17
   Most Important, Sharp Focus . . . . . . . . . . . . . . . . . 17
   How Sharp is the Depth of Field? . . . . . . . . . . . . . . 19
From Focusing Screen to Auto-Focus . . . . . . . . . . . . . 21
   Stage 1: Focusing Aids . . . . . . . . . . . . . . . . . . . . . 21
   Stage 2: Auto-Focusing . . . . . . . . . . . . . . . . . . . . . 23
Sharpness à la Minolta . . . . . . . . . . . . . . . . . . . . . . . 25
   A Computer for Sharpness . . . . . . . . . . . . . . . . . . . 25
   Sharpness by ''Crankshaft'' . . . . . . . . . . . . . . . . . 28
   The Sharpness Memory . . . . . . . . . . . . . . . . . . . . . 30
   Problem Areas with Auto-focusing . . . . . . . . . . . . . 32
   Where DO the Blurred Pictures come from? . . . . . . 40
Description of the Minolta 7000 . . . . . . . . . . . . . . . . 40
   Television in your Camera . . . . . . . . . . . . . . . . . . . 41
   Many Keys to the Goal . . . . . . . . . . . . . . . . . . . . . 43
   Three Old Aquaintances . . . . . . . . . . . . . . . . . . . . 46
   Good Contacts . . . . . . . . . . . . . . . . . . . . . . . . . . . 48
   For Power and Security . . . . . . . . . . . . . . . . . . . . . 49
   The Film Compartment . . . . . . . . . . . . . . . . . . . . . 50
   Clear and Informative . . . . . . . . . . . . . . . . . . . . . . 56
   Of One Piece . . . . . . . . . . . . . . . . . . . . . . . . . . . . 57
   All in All . . . . . . . . . . . . . . . . . . . . . . . . . . . . . . . 58
The Agony of Choosing the Right Film . . . . . . . . . . . 58
   In Praise of Shades of Grey . . . . . . . . . . . . . . . . . . 59
   Colour Prints or Colour Slides . . . . . . . . . . . . . . . . 61
   Slide Film the Favourite . . . . . . . . . . . . . . . . . . . . 64
Special Films for Special Purposes . . . . . . . . . . . . . . . 65
   All about Film Speed . . . . . . . . . . . . . . . . . . . . . . . 68
The Shutter . . . . . . . . . . . . . . . . . . . . . . . . . . . . . . . 74
The Aperture . . . . . . . . . . . . . . . . . . . . . . . . . . . . . . 77
Doubling and Halving Complement Each Other . . . . . 80
Exposure . . . . . . . . . . . . . . . . . . . . . . . . . . . . . . . . . 82
   Exposure Measurement – How Light is it Outside? 82

What Follows from the Brightness Measurement? .    83
The Simplest Aid to Creativity . . . . . . . . . . . . . . . . . . .    84
Depth of Field – or the Antlered Grandfather  . . . . .    84
Blur – or Camera Shake?  . . . . . . . . . . . . . . . . . . . .    89
With or without ''Wiping Effect''  . . . . . . . . . . . . . . .    91
Programme Mode –
You only have to Press the Release Button  . . . . . . .    93
Programme – According to the Lens  . . . . . . . . . . . .    94
Programme – According to the Subject  . . . . . . . . . .    97
Aperture According to Your Wish –
Speed According to Your Wish . . . . . . . . . . . . . . . . . . .   100
Choice of Aperture  . . . . . . . . . . . . . . . . . . . . . . . . .   100
Choice of Shutter Speed . . . . . . . . . . . . . . . . . . . . . .   102
Self-Determination . . . . . . . . . . . . . . . . . . . . . . . . . .   103
Everything has been Thought Of  . . . . . . . . . . . . . . .   104
Subjects Which Don't Fit the Scheme  . . . . . . . . . . . . .   104
Against the Light  . . . . . . . . . . . . . . . . . . . . . . . . . . .   107
White on Black  . . . . . . . . . . . . . . . . . . . . . . . . . . . .   110
Black on Black and White on White . . . . . . . . . . . . .   111
Technique of Bracketing  . . . . . . . . . . . . . . . . . . . . .   112
The Trick with the Film Speed . . . . . . . . . . . . . . . . .   113
Camera Clear for Action! . . . . . . . . . . . . . . . . . . . . . .   114

**The Minolta Lenses**  . . . . . . . . . . . . . . . . . . . . . . . . .   118
Space-Creating Perspective  . . . . . . . . . . . . . . . . . . . .   118
Reproduction Ratio: the Nearer, the Larger  . . . . . . . .   120
Specialities à la Minolta . . . . . . . . . . . . . . . . . . . . . . .   122
Banish Stray Light  . . . . . . . . . . . . . . . . . . . . . . . . . . .   125
The Shortest of All: AF 20mm f/2.8; AF 24mm f/2.8  . .   126
The Universal Wide Angle Lenses: AF 28mm f/2; AF
28mm f/2.8; AF 35mm f/1.4; AF 35mm f/2  . . . . . . . .   128
The All Round View: AF 16mm f/2.8 Fisheye  . . . . . . . .   131
Quite Normal: AF 50mm f/1.4 and 50mm f/1.7  . . . . . . .   132
Not Quite Short – But Not Long Either: AF 85mm
f/1.4; AF 100mm f/2; AF 135mm f/2.8 . . . . . . . . . . . .   133
The Universal Telephoto: AF 200mm f/2.8 Apo  . . . . . .   136
A Lot of Lens for a Lot of Money: AF 300mm f/2.8 Apo;
AF 600mm f/4 Apo . . . . . . . . . . . . . . . . . . . . . . . . . .   137

Tele Converters: AF 1.4X; AF 2X . . . . . . . . . . . . . . . . . 139
Specialists in Close-up: AF-Macro 50mm f/2.8; AF-
    macro 100mm f/2.8 . . . . . . . . . . . . . . . . . . . . . . . . 140
Fixed Focal Length versus Zoom . . . . . . . . . . . . . . . . 146
The Zoom Focal Lengths . . . . . . . . . . . . . . . . . . . . 149
The Three Universals: AF 28-85mm f/3.5-4.5;
    28-135mm f/4-4.5 and 35-105mm f/3.5-4.5 . . . . . . . . 151
A Perfectly Normal Zoom: AF 35-70mm f/4 . . . . . . . . . 153
The Wide Angle Zoom: AF 24-50mm f/4 . . . . . . . . . . . 154
The Telephoto Zooms: AF 70-210mm f/4; AF
    100-200mm f/4.5; AF 75-300mm f/4.5-f/5.6; AF
    80-200mm f/2.8 Apo . . . . . . . . . . . . . . . . . . . . . . . 155
The Reflex Mirror: How the Picture Gets into the
    Viewfinder . . . . . . . . . . . . . . . . . . . . . . . . . . . . . 158

**Pocket Sized Sun: Flash Guns** . . . . . . . . . . . . . . . . 162
Program Flash 2800 AF . . . . . . . . . . . . . . . . . . . . . . 164
   Guide Number . . . . . . . . . . . . . . . . . . . . . . . . . . . 164
   Metering through the Lens . . . . . . . . . . . . . . . . . . . 165
   Filling-in Made Easy . . . . . . . . . . . . . . . . . . . . . . . 167
   Slow Speed Plus Flash for Effect . . . . . . . . . . . . . . . 169
   Synchronisation Time . . . . . . . . . . . . . . . . . . . . . . 170
   Wide Enough Illumination Angle . . . . . . . . . . . . . . . 171
   Corrected Flash . . . . . . . . . . . . . . . . . . . . . . . . . . 172
   Accessories for Flash . . . . . . . . . . . . . . . . . . . . . . 172
Program Flash 4000 AF . . . . . . . . . . . . . . . . . . . . . . 175
   Automatic Power Zoom . . . . . . . . . . . . . . . . . . . . . 175
   Choice of Power Output and Flash Range . . . . . . . . . 175
   The Flash Which Comes round the Corner . . . . . . . . 176
Program Flash 1800 AF . . . . . . . . . . . . . . . . . . . . . . 178
Macro Flash 1200 AF Set . . . . . . . . . . . . . . . . . . . . . 178

**A Trio of Backs** . . . . . . . . . . . . . . . . . . . . . . . . . . . 179
Program Back 70 . . . . . . . . . . . . . . . . . . . . . . . . . . 179
Data back 70 . . . . . . . . . . . . . . . . . . . . . . . . . . . . . 182
Program Back Super 70 . . . . . . . . . . . . . . . . . . . . . . 182
Photos without a Photographer . . . . . . . . . . . . . . . . 183

**Other Facilities** . . . . . . . . . . . . . . . . . . . . . . . . . . . . . 186
   For Better Sight . . . . . . . . . . . . . . . . . . . . . . . . . . . 186
   The Camera on a Long Lead . . . . . . . . . . . . . . . . . . 187
   Filter or No Filter? . . . . . . . . . . . . . . . . . . . . . . . . . 187

**Hunt Your Subjects Freely** . . . . . . . . . . . . . . . . . . . 190
   Many Colours Spoil the Broth . . . . . . . . . . . . . . . . . 190
   Get the Subject You Want! . . . . . . . . . . . . . . . . . . . . 191
   I Don't Know What to Photograph . . . . . . . . . . . . . . 193

**Minolta AF Lenses: Important Technical Data** . . 197

**Index** . . . . . . . . . . . . . . . . . . . . . . . . . . . . . . . . . . . . . 199

# FOREWORD

When it was launched in 1985 the Minolta 7000 was the first of a completely new generation of 35mm SLR cameras. Prior to that there had been attempts by other manufacturers to introduce automatic focusing in reflex cameras, hoping to repeat the success it had achieved in giving a new impetus to the 35mm compact camera. These attempts were not very successful, the main problem being the need to provide a measuring and focusing system that would be applicable to the wide range of lens focal length used in a modern SLR. Then Minolta, who had kept clear of these false starts, burst on the scene with a total system. They had a camera different from anything seen before, with completely new, but reliable technology. Furthermore, it was accompanied by a complete family of lenses. It thus offered the photographer not just the promise of things to come, but a total system there and then, ready for use from day one. It rendered previous Minolta camera systems obsolete. No lenses or other accessories fitting into the camera bayonet could be used on the new Minolta. The decision to have a new bayonet was a very big commercial risk, but it did not deter purchasers and the Minolta 7000 became one of the world's best-selling cameras. Since then the number of Minolta AF lenses available has more than doubled.

Several rivals from other well-respected manufacturers have appeared on the scene in the brief period since the launch. Minolta had settled on a system in which the drive motor for the focusing was within the camera body and coupled to the lens by a driveshaft. Some of these rivals employ separate motors inside the lenses, others kept to their existing bayonet design so that their older lenses would still be compatible either via an adapter or with manual focusing. But the original Minolta concept was so sound that the Minolta 7000, now joined by the 5000, simpler and offering fewer facilities and the professional 9000, is still extremely popular.

*A difficult subject, but full of creative opportunities for the expert: the human body. Photo: Peter Raas*

# THE BIRTH OF A FAMILY

Great events are often foreshadowed by rumour. Accordingly the world of photography should have been alive with anticipation before Minolta staged their big coup at the beginning of 1985. But Minolta managed to keep the project a complete secret, as if it had been planned by the General Staff, and it paid off. Only here and there did rumours appear about a "completely new Minolta"; only here and there was it rumoured that it would put everything currently on the market into the shade.

Then came the huge surprise: Minolta introduced not just a camera with one or two lenses and a few bits of equipment as is usual in the field of photography, but a complete system. Instead of an offspring, which the friends of the big Minolta camera family had expected, a new family was presented, and not just on paper. Interested parties were able to get to know all members of the family personally, but the Minolta surprise had been achieved.

So, what was presented to the amazed public?

The focal point of this new system is of course a camera, the MINOLTA 7000, which even by its name indicates that it stands outside the well-known tried and tested X-Series (X-300, X-500 and X-700) and which differs in its design from the known Minoltas.

Once again with the 7000 Minolta presented a camera with "all its bits and pieces", and people who know the Minolta philosophy expected that the 7000, as with the XD-7 in 1977 and the X-700 in 1982, was launched as a flagship and that "fleet" models would follow in its wake in due course, offered as cheaper second cameras for photographers who are unable or who do not want to make full use of the extensive equipment of the "7000". In fact Minolta were so confident of their new system that they went the other way and now offer a professional version, the Minolta 9000.

Talking about cheaper models: naturally the "7000" is not an expensive camera. At its launching there were voices

which recommended Minolta to raise its price by £75 or £100. Even if the Minolta people had listened to this advice the Minolta 7000 would not have been expensive. As they did not do so it seems hardly believable that so much technology can be offered so cheaply. Something else on the subject of price: if a camera like the Minolta 7000 should become cheaper still, this does not mean that you, who immediately grabbed the opportunity and paid more, have been taken for a ride by Minolta. The low prices are being set by the dealer who cuts his profit margin when selling a camera and wins a customer in the process.

How comprehensively equipped is the Minolta? It offers:

Auto-focus system integrated in the camera body

Automatic choice of exposure programme to match the focal length

Optional shutter or aperture priority

Manual exposure compensation

Automatic DX-film indexing

Built-in winder

Wide scope for exposure correction

Indicator for all important data in and on the camera

Facilities for attaching comprehensive accessories, from flash guns to data- and control-backs

If you cannot imagine what this or that facility is supposed to be, or you do not know what on earth all this is any good for, we are only at the beginning of the book. There are many pages ahead of us in which I shall attempt to bring all this closer to you.

Apart from this amazing camera at an amazing price, a dozen lenses were also introduced, all newly designed for the new Minolta 7000. The lenses ranged from a (super-) wide-angle to a (super-) telephoto and included five zoom lenses. This meant that the Minolta was suitable for the amateur who did not want anything else but simply to make good pictures. For him two zoom lenses would cover the whole focal length range for his needs. But the devoted amateur who wanted to put together the right equipment with several lenses was also catered for.

Professionals were also tempted by Minolta and they now have a model, the Minolta 9000, designed primarily to suit their needs.

The list of lenses has more than doubled since those early days. Here it is at a glance, but you will find that the table at the back of the book will give you the full specifications:

AF 16mm f/2.8 Fisheye
AF 20mm f/2.8
AF 24mm f/2.8
AF 28mm f/2
AF 28mm f/2.8
AF 35mm f/1.4
AF 35mm f/2
AF 50mm f/1.4
AF 50mm f/1.7
AF 85mm f/1.4
AF 100mm f/2
AF 135mm f/2.8
AF 200mm f/2.8 Apo
AF 300mm f/2.8 Apo
AF 600mm f/4 Apo
AF 24-50mm f/4
AF 28-85mm f/3.5-4.5
AF 28-135mm f/4-4.5
AF 35-70mm f/4
AF 35-105mm f/3.5-4.5
AF 70-210mm f/4
AF 75-300mm f/4.5-5.6
AF 80-200mm f/2.8 Apo
AF 100-200mm f/4.5
AF Macro 50mm f/2.8
AF Macro 100mm f/2.8
AF 1.4X Tele Converter Apo
AF 2X Tele Converter Apo

The system is complemented by four flash guns of which the possibly most popular, the Program Flash 2800 AF, was present at the launch. The more powerful and versatile

# The operating functions of the Minolta 7000

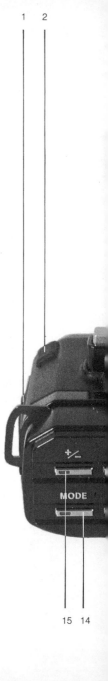

1 Back cover release
2 Remote control terminal
3 Lens release
4 Focus-mode switch
5 Self-timer LED
6 Operating button
7 Main switch
8 Program reset
9 Shutter speed keys
10 Data panel
11 Accessory shoe
12 DRIVE mode key
13 Film speed key
14 Exposure mode key
15 Exposure adjustment key
16 Tripod socket
17 Eye piece
18 Film window
19 Control grip contacts

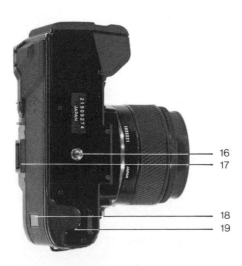

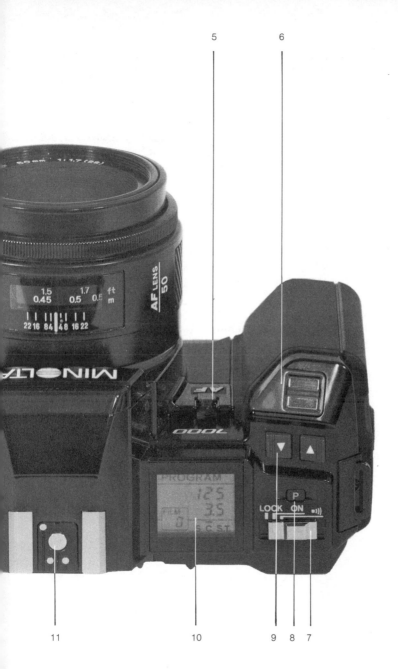

5 6

11 10 9 8 7

15

Program Flash 4000 AF and the small and pocketable Program Flash 1800 AF came later, together with the close-up specialist's Macro Flash 1200 AF Set.

The Program Back 70, which gives unmanned camera control as well as data imprinting, was also available right from the start. It was joined later by the much more versatile, professionally-orientated Program Back Super 70, as well as the Data Back 70 for those who only need to imprint the date or time.

Are complete systems not automatically connected with growing pains? Definitely not: the electronics which control the exposure in the Minolta 7000 are based upon many years experience. The electronics which control the focusing adjustment were tested again and again very thoroughly over the many years of development, in the research stages and in the pre-production prototypes, and only let loose on the public when failure was impossible. What about optical quality of the lenses? When you have been involved in the business of lenses for as long as Minolta, and have manufactured millions of lenses, you know what is important; you have the know-how to put these requirements into action, and also have the financial resources to develop special types when ordinary technology does not promise the best results. In other words, as new as the Minolta 7000 system may be, it is part of the Minolta tradition and it has therefore been guaranteed that the requirements of high quality will be fulfilled.

# A Few Words on the Subject of Focusing

When my father wanted to take a photograph of me as a young child, he looked up at the sky and then usually set the camera at $^1/_{125}$sec with an aperture setting of f/8. He then looked at me, and I could see that he was measuring the distance between himself and me in one metre steps. He then set this distance on the Voigtlander Vito B. When I look at these photographs now I can say that the exposure is correct and the pictures properly focused. Therefore we do not need the automatic system, which ensures correct exposure, most definitely not! In those days my father used a black and white print film, and if he had made a slight exposure error this could be corrected on printing. His Vito B had, or I should say still has, because I still keep it in its old age, a 50 mm lens with a speed of f/3.5, which in simple words means that even with the aperture completely open the depth of field was big enough to compensate for small misjudgements in focusing.

Nowadays, when exposing colour print films, one should be more careful with the exposure setting. If a slide film is used one cannot do without an exposure meter, and really one would not want to do without the automatic exposure which makes life so much easier, but we shall get back to this later.

People who take photos with lenses of longer focal length or greater speed must use focusing aids, and they will appreciate auto-focus lenses as a great help.

## Most Important, Sharp Focus

It is extremely difficult to determine, according to the people who deal with optics and laws of reproduction, because it is made up of a variety of elements. The individual determinants are the capacity of the lens for the reproduction

of contrast and of resolution. Therefore optimum focusing could be attributed to a lens which reproduces 40 black/grey pairs of lines from a chart and which reproduces the contrast between the black and the grey exactly, and without blurring the borders between the lines.

This is the theory, but as you did not purchase your Minolta 7000 with the intention of becoming a theoretician, we should rather approach focusing from the practical point of view. You know as well as I do what is meant by a blurred picture: a picture with fuzzy outlines, and one on which Auntie Mabel can only be recognised by the flowery dress, rather than her face.

To avoid exactly that, blurred pictures that is, the lens can be focused, or one could say set precisely in front of the film. There are different methods of focusing. Plate cameras and some medium sized cameras have bellows which connect the lens and the camera body without letting in light. During focusing the whole lens is moved forwards or backwards. The greater the distance between the lens and the film, the shorter the photographing distance in which a sharply focused picture results. The camera is focused at infinity when the distance between lens and film is at a minimum.

Most modern cameras do without bellows, which re-emerge only for extremely close pictures ("extension bellows"). The lens head only is moved backwards or forwards, and the overall length of the lens is increased or decreased by a relatively small amount, but enough to disturb the equilibrium of the longest focal lengths. Imagine a flexible horizontal pole on which a weight is being moved forward! The more the weight is pushed forward, the more it will bend downwards. In a similar way this happens with a very long zoom lens when set for a short distance. It pulls downwards and therefore puts leverage on the bayonet. Because of this very long lenses often have a built-in tripod thread so that the support is attached at the centre of gravity. An alternative design which avoids this irritating elongation of a lens during focusing is internal focusing by which groups of elements only

are moved within the lens barrel so that its overall length is not affected.

## How Sharp is the Depth of Field?

Depth of field is the distance from the nearest to the furthest planes in the subject that appear to be represented sharply on the film. It covers some distance in front and some distance behind the plane of focus. I have said "appear" to be represented sharply because a point in the image is only a sharp point on the film if it is actually at the plane of focus. Away from the plane of focus it will be spread into a disc, called the circle of confusion, which gets bigger the further the point is from the plane of focus. Below a certain size, the human eye is unable to distinguish between a point and a circle; this means that if the circle of confusion is below that size it will appear to be a point and we may think a feature of the subject is in focus when in fact it is not. This is the basis of the phenomenon of depth of field; in reality it is an optical illusion. For photographic purposes the limits of depth of field are defined as being when the circle of confusion becomes greater than 0.033mm in diameter.

The light rays from a point emerging from a lens after passing through it are in the form of a cone with its point at the plane of focus. Beyond the plane of focus they open up again in the form of an inverted cone. If the aperture in the lens is closed to a smaller opening, then the rays of light allowed through will be reduced to a narrower beam and the cone of light emerging will then be narrower and more sharply pointed. If the aperture is opened up then the cone will be broader and less pointed. The broader and less pointed the cone, the shorter will be the distance from the plane of focus at which the circle of confusion will reach its critical size. Conversely, it will be at a greater distance with a narrower cone. Hence the aperture has an important effect on the depth of field.

For similar reasons both focal length and the distance of the subject from the lens also influence the depth of field. For each of these three factors there is a simple rule to remember. Here they are:

● The depth of field is greater for smaller apertures than for larger ones
● The depth of field is greater for short focal lengths than for longer ones
● The depth of field is bigger for large distance settings than for short ones

A fourth rule can be added

● The first three rules can cancel each other out

In practice this means the following. Let us suppose you have fixed the AF-Zoom 28-85mm to your camera. With the same aperture and from the same position, that means with the same distance setting, the depth of field is greater at 28mm than at 85mm. You can, however, bring the depth of field at 85mm into line with that at 28mm if you select the aperture at 85mm to be much smaller than that for the shortest focal length. You can also keep the aperture at the same setting, but increase the distance to the subject. At 2m, aperture f/4 and 28mm focal length the depth of field is no bigger than at 6m, aperture f/4 and 85mm focal length.

I am going to test your memory, I would like to ask you to remember this not only for the chapter ''auto-focus'', but also the the chapter about picture creation.

# From the Focusing Screen to Auto-Focus

The method by which my father was able to establish the distance with his Vito-B is without doubt the simplest, and quite useful if one has a good eye and is used to a larger depth of field.

How else can one establish sharp focus? That means that a sharp picture is being projected onto the film, even with a fast lens (small depth of field) or with long focal lengths (also small depth of field), both conditions where it is difficult to estimate accurately.

## Level 1: Focusing Aids

Let us begin right at the beginning, with the focusing screen, which served a useful purpose for focusing with plate cameras years ago (when the photographer had to vanish under the well-remembered black cloth). The focusing screen serves as a "film substitute" before the picture is taken, and shows the picture which is projected by the lens as the film will see it, and of course it also shows if a picture is blurred or not. By this means the photographer can judge the optimum sharpness by the appearance of the image on the screen. So that he is not distracted by reflections and stray light, and that the picture will not be flat because of scattered light, he has to duck under the said black cloth.

The focusing screen has not become extinct as you might think; it is still the only focusing aid in view cameras and it can also be used for examination of the subject in medium sized and 35 mm reflex cameras, as well as for focusing. Manufacturers make great efforts to brighten the focusing screens of their 35 mm cameras. The result at Minolta is the micro-honeycombed focusing screen, which shows the subject bright and clear. However, most photographers rely on the focusing aids, on the micro prisms and the split image range finder. Both do appear separately on special screens,

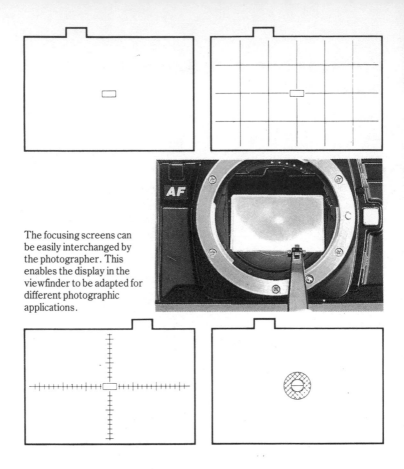

The focusing screens can be easily interchanged by the photographer. This enables the display in the viewfinder to be adapted for different photographic applications.

but usually turn up together with the micro prisms surrounding the split image indicator as a ring on the common universal type of screen.

The micro prism screen is made up of microscopically small tetrahedron shaped prisms (tiny pyramids), whose edges measure less than 0.1 mm. If focusing is not sharp, the microprisms break down the picture of the subject into innumerable single pictures, the micro prism spot or ring flickers and this indicates the lack of sharpness quite clearly. Micro prisms are especially helpful as a focusing aid if the subject is not geometrical. In contrast to this the split image

indicator is more useful for subjects which are composed of many lines. Two measuring wedges, which have been placed against each other (they are prisms) have been set into the focusing screen and depict two images placed against each other. If the subject is badly focused the resultant non-alignment of the two images can be seen best by looking at lines running through the picture. Sharpness is achieved when the lines align perfectly.

It is not only single lens reflex cameras with which sharpness can be readily established. Range-finder cameras of the Leica type are equipped with very exact distance meters. They have double-image rangefinders, by which pictures are projected into the viewfinder by two different optical systems. The two images are out of line with each other if focusing is incorrect. To align the images a mirror turns in one of the optical systems; its movement is proportional to the focusing movement of the lens. In effect this method of measurement is based on triangulation, the base (the distance between the two optical systems) and two angles determine the distance.

## Level 2: Auto-Focusing

For many years there was talk of leaving the focusing to a machine, but apart from a few prototypes which did not seem to work very well, the waiting world or photography saw nothing.

Only in 1978 was the first auto-focus camera offered to the market – a 35mm viewfinder camera. Since then AF compact cameras have been used everywhere. It is not surprising that it should be in the sector of viewfinder cameras that auto-focusing was able to succeed. Just remember the pictures my father took of me! The compact viewfinder cameras of today are equipped with wide angle lenses of greater depth of field; and because they are usually used outside in bright sunlight, or indoors with a flash, the light is bright enough for a small aperture and hence greater

depth of field. Focusing inaccuracies are made good by the depth of field, and if not? Very few pictures from an AF-compact camera are ever enlarged to more than 9 x 12 cm when blur would be plainly noticed.

Photographers did not approve of auto-focus as far as single lens reflex cameras were concerned. Why? The answer is simple: the choice was too limited, the choice of lenses that is.

In only a single example could a range of different focal length lenses be used with auto-focus convenience. A converter not only lengthened the focal length, but also took over the control of focusing. But prime lenses of a speed of f/2 were required, which excluded zoom lenses, and only lenses of longer focal length could be used, which were not only very large but also expensive.

Apart from this, a few 35-70's were offered as AF lenses and fixed focal length 50's, 85's and 200's; not a very good choice.

These lenses had another disadvantage: all of them carried the focusing meters which controlled the groups of elements on focusing; many of them also carried the batteries and some of them also the complete auto-focusing system. No wonder then that these lenses could not possibly be small and dainty, although quite a lot had been achieved in the way of miniaturisation. You will excuse this little excursion which has shown on the one hand that a system like that of the Minolta 7000 does not just appear suddenly and unexpectedly out of the blue, and on the other hand how far ahead of all the other hesitant attempts the Minolta 7000 stands with its well thought out and finished system.

# Sharpness à la Minolta

Just take a split-image rangefinder, substitute a charge coupled device (in computer language a CCD-sensor) for the human eye, and there is your automatic. Naturally this is only simple in principle. In cruel reality the following also play their roles: a lens ROM-IC, a C²PU, an AF-CPU with RAM, a calculator and control unit, an auto-focus interface, an IC-interface, an IC-Motor-IC and an encoder as well as twin separator-lenses, lens contacts, the lens motor drive and not forgetting the viewfinder LED's. Quite a lot of hardware, and if I were to explain everything in minute detail both of us would be computer experts as a result, and would have forgotten all the joy of practical photography because of the seriousness of the electronic theory.

## A Computer for Sharpness

Let's be brief! The image of the subject passes through the lens, strikes the mirror, onto both separator lenses which direct the two split images onto the charge coupled device (which is made up of 128 single elements) Depending on how out of focus the subject is, because the lens is still set from the previous picture, the split images appear more or less offset from each other. From this degree of non-alignment the auto-focus computer senses, with its RAM and its calculator and its whateverelse, how far the lenses have to be moved, and in which direction, in order to achieve the optimum sharpness.

If something seems odd to you now, then you have been paying attention. Of course, the AF-computer has to know at which position the lens has stopped and which movements have to be made to get from distance A to distance B. It is exactly this information which is being passed from the lens by means of the auto-focus contacts in the lens bayonet. Apart from this, the camera will also learn which apertures can be used (which is only of interest later on) and it will be

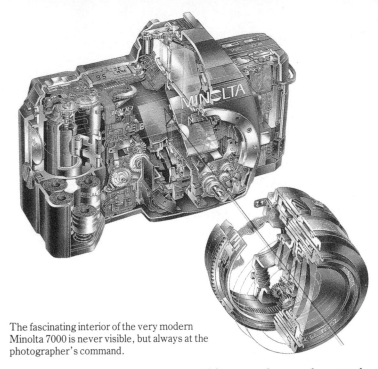

The fascinating interior of the very modern Minolta 7000 is never visible, but always at the photographer's command.

told the focal length of the lens, and for zoom lenses the actual set focal length. In order to dampen your euphoria as a Minolta fan I must tell you that this is not all that new; others before have used this information in order to reduce the danger of camera shake. This of course is also being done by Minolta (and we shall return to this at a later point), but the Minolta design engineers have come up with an addition. Now please remember our theorem about the depth of field, or more precisely the one about depth of field and focal length. To be precise, the shorter the focal length, the greater the depth of field (proviso: as long as set distance and aperture remain unchanged).

Hence your Minolta 7000 knows which focal length you intend to use, and it knows whether this is a focal length with large or small depth of field, and it also knows whether the focusing has to be very precise (long focal lengths with

''short'' depth of field). According to this information auto-focus may take more or less time to focus.

Here are some examples of actual focusing times for different lenses moving from their shortest focusing distances to infinity.

| Lens | Setting time/auto-focus |
|------|-------------------------|
| AF 24mm f/2.8 | 0.25m to ∞ in 0.35sec |
| AF 28mm f/2.8 | 0.30m to ∞ in 0.35sec |
| AF 50mm f/1.4 | 0.45m to ∞ in 0.60sec |
| AF 50mm f/1.7 | 0.45m to ∞ in 0.60sec |
| AF 135mm f/2.8 | 1.00m to ∞ in 0.65sec |
| AF 300mm f/2.8 | 2.50m to ∞ in 1.15sec |
| AF 28-85mm f/3.5-4.5 | 0.80m to ∞ in 0.85sec |
| AF 28-135mm f/4-4.5 | 1.50m to ∞ in 0.45sec |
| AF 35-70mm f/4 | 1.00m to ∞ in 0.45sec |
| AF 35-105mm f/3.5-4.5 | 1.50m to ∞ in 0.55sec |
| AF 70-210mm f/4 | 1.10m to ∞ in 1.20sec |
| AF-Macro 50mm f/2.8 | 0.20m to ∞ in 1.85sec |

Naturally, this table has been shifted around a little because different shortest focusing distances are the underlying criteria, but if one also takes into account the focusing time from 1m to infinity the tendency remains the same. On the 24mm f/2.8 the motor drive turns in 0.15 seconds; on the 135mm f/2.8 in 0.65 seconds, more than four times as long.

# Sharpness by "Crankshaft"

"The motor drive then turns" I just wrote. How is that to be understood? This is one of the good ideas from the Minolta engineers. As I am sure you will remember, all other single lens reflex auto-focus attempts started with lenses. These had a built in motor for lens and distance setting, which was only achieved elegantly in one case.

One of these motors in an AF-lens naturally costs money, and who has to pay for that? No doubt you will not have to guess three times in order to arrive at the right answer. Such a motor also weighs a bit, and who has to carry that around?

Therefore, it was decided at Minolta to provide just one motor for all AF-lenses and to position it inside the camera. Now the only problem to be solved was how the motor inside the camera was to move the lenses in their mounts. The answer has been available for as long as there have been motor cars, which have the engine in the front and the driving wheels at the back. One uses a shaft which protrudes from the camera bayonet with a screwdriver-like blade and which fits into a screw-head-like slot in the lens bayonet. The revolutions of the AF-motor in the camera are thus transmitted to the lens.

Everything in this auto-focus system depends on a perfect interaction between the lens and the camera body, that is from the electronic data-transfer to the mechanical control of the focusing. Unfortunately that means that only the special AF lenses with the new Minolta A-Bayonet can be attached to the Minolta 7000. MD or MC-lenses cannot be used even in the manual mode. That is a pity, because people who have so far sworn by Minolta X-500 or even cherished a SRT303b, have to get rid of their equipment or build up a parallel outfit.

Let us remain with the auto-focus control on your Minolta 7000 for just another moment! In contrast to other systems, in which the lens brackets the correct focus by moving backwards and forwards, the Minolta 7000 pulls the lens within one movement to the point of focus and then stops.

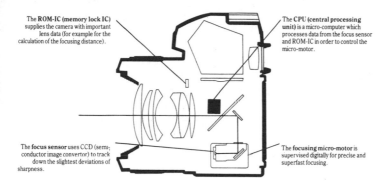

The **ROM-IC (memory lock IC)** supplies the camera with important lens data (for example for the calculation of the focusing distance).

The **CPU (central processing unit)** is a micro-computer which processes data from the focus sensor and ROM-IC in order to control the micro-motor.

The **focus sensor** uses CCD (semi-conductor image convertor) to track down the slightest deviations of sharpness.

The **focusing micro-motor** is supervised digitally for precise and superfast focusing.

All the important components of the auto-focusing system are housed in the camera body. Only the ROM-IC is part of the lens mechanism.

This is a plus point when speed in focusing is important. For this the Minolta lenses use quite a simple trick: just as a train-driver, who would not rush into a station at full power and then apply the emergency brake, the motor drive moves first of all at full speed, then reduces speed in four steps until it arrives at slow speed at the point of exact focus, where it stops.

Nevertheless all this is happening at a speed like greased lightning. If you once again cast your eye at the table with the focusing times, and remember that the whole focusing range only has to be traversed very rarely, so the focusing times are even shorter, then you must agree with me.

These activities are triggered simply by your index finger touching the shutter release and lightly depressing it. That seems a great advantage at first sight, but on second thoughts a great disadvantage.

# The Sharpness Memory

In order to explain about the disadvantage I must tell you that the distance is not measured at all. When you look into the viewfinder of your Minolta 7000 you will see a small rectangle, the auto-focus measuring field, or one could say the reticle for automatic focusing. The important section of the subject which needs to be absolutely sharp has to be placed in the rectangle. I hear you ask what if that part is not supposed to be in the middle of the picture? Therein lies the advantage of the auto-focusing being started with a light pressure on the button whilst it is fully depressed to release the shutter. The focus setting you have just seen in the middle of the picture is stored all the time the release button is kept partly depressed. Your Minolta 7000 then does not care at all whether you have moved the measured part of the subject to the top right-hand corner because it was the spire clock in a picturesque village in the mountains that needed to be in focus, or whether you moved it to the left side of the picture because you wanted to show the mountains in the background next to your better half.

So where is the disadvantage? Let us imagine you are following your daughter at a tennis match. As soon as you lay your finger on the shutter release button the Minolta is focusing, no matter whether your daughter is playing a copybook backhand (when you would actually release) or whether she is desperately chasing the ball (which of course you would not want to capture in a picture because you are tactful, kind and helpful). What one does in the second case is to follow her, keeping her in the measuring field and only pressing the button when you really want to take the picture. This cumbersome procedure is eased somewhat if you pre-focus on a distance which is close to the one likely to be needed and taking a substitute measurement. Because of this, (a) the degree of unsharpness in the viewfinder is less, and (b) the focusing time is also shortened.

This is valid if you use your Minolta 7000 in the single

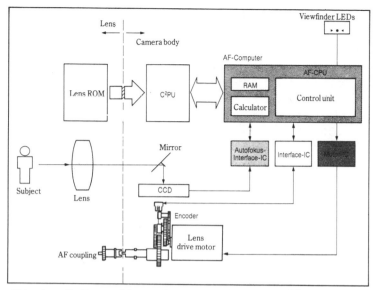

This schematic diagram of the auto-focus system shows which components have to interact in order that the Minolta 7000 can focus quickly and reliably. A special flash unit can be included in the circuit so that focusing can take place in the dark.

picture mode, that means if the built-in motor transports the film to the next frame after every exposure and then stops. However, you can switch to series (this, also, will turn up at a later point) and expose two frames per second. Now the thing with the finger on the release button is paying off. As long as you leave your finger there the focus is freshly determined for every picture. If the subject should move towards you or you should get nearer to the subject, it stays in focus.

A small problem with this: you must keep the subject exactly in the small rectangle of the viewfinder because the Minolta 7000 is reacting so fast. As soon as the subject is no longer precisely in this rectangle and the background gets into the measuring field the Minolta 7000 will focus on the background, immediately and without any idea that the background may be totally unimportant to you.

# Problem Areas with Auto-Focus

With this, we have stealthily, quietly and softly approached a new subject - the practicalities of auto-focus and the problems your Minolta 7000 will give you.

I hope you are not terribly worried. Quite naturally the Minolta 7000 will give you problems, and naturally I shall tell you about these problems. In doing so I will be unfair to Minolta because I am not going to list all the times when the automatic focusing will serve you perfectly, as I do not intend to write several Minolta 7000 volumes. A few percent of all possible pictures with the Minolta 7000 will try to give the impression that the camera is unreliable as far as sharpness is concerned. Don't let me mislead you with this, always remember that if cameras are doing everything automatically there is no need for photographers!

Let us get down to the practicalities of auto-focus, and to the occasions when you cannot rely on the auto-focus computer and whatever is connected with it. The whole thing is really quite simple; whenever you would have problems with the split image indicator during focusing with a conventional SLR, then the Minolta will also experience problems with sharpness. If you have been a member of the photographic hobby guild for a while you will know by now what I am about to say. However, if the Minolta 7000 is your first single lens reflex camera you are just as clever as you were before. Where and when can problems occur?

Very light and very dark subjects

In conditions of extreme brightness or dimness the very high or very low light energy overwhelms the split images, which the CCD-sensor needs to be able to distinguish in order to recognise the point of sharpness.

Subjects with very weak contrast

The lines which aid the split-image rangefinder during focusing are the result of the contrast between two areas of

*The photographer who understands how to observe is never without a subject, as these two pictures prove. What is important is that the subject should fill the format of the picture, and that is a major benefit of zooms. Photos: Helmut Sandner (above) Ferdinand Michel (below)*

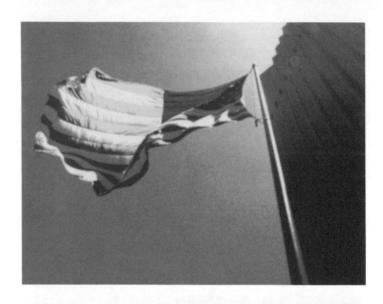

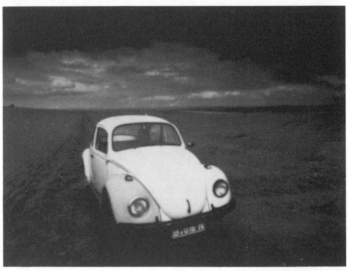

*Accents of light distinguish these pictures. The flag with the sun shining through it stands out well, and the Beetle seems to be illuminated by a spot light. Photos: Ingo Jezerski (above) Fernand Domange (below)*

different light intensity. If these lines are missing, because the whole subject is of a similar tone, you will have problems in focusing with the split-image rangefinder; however, you can switch to the micro-prism ring. In these circumstances the AF-computer is also unable to find any prominent part of the picture which it can use to determine distance.

## Subjects with predominantly horizontal lines

Split image rangefinders have been arranged diagonally in some cameras so that horizontal lines are cut in the same way as vertical ones. A line, which runs parallel to the boundary between the rangefinder wedges cannot be used for focusing. Your Minolta is just as unable to get on with horizontal lines, but who takes photos of venetian blinds continuously?

## Subjects with evenly recurring line structures

If you have ever tried to focus on a tiled roof with a split image indicator, you will know how wrong one can be. The vertical separating lines between the tiles are cut clearly and shifted against one another, but on focusing one notices that all lines look the same. If one has not got a micro prism ring in the focusing screen one has to be very careful not to make the line between the second and third tile congruent with, for example, the first and the second tile, believing wrongly that one has focused properly. The CCD-sensor also has the same difficulties. But whereas you might actually get caught out and only notice the lack of sharpness when the picture lies in front of you, the Minolta smells a rat immediately and lets you know that it cannot be of service to you. (Naturally this is valid for all occasions when the AF-system is not functioning, not just for even line structures.

## Subjects which move very quickly

Even though the automatic focusing works very quickly, the AF-computer still needs a little time in order to establish the sharpness, and the motor also needs a little time to position

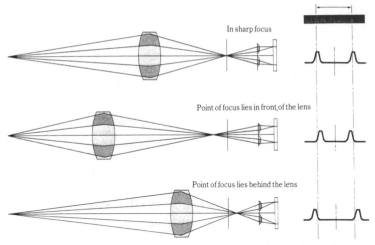

In sharp focus

Point of focus lies in front of the lens

Point of focus lies behind the lens

The camera compares the automatic measurement with reference data and establishes whether the lens has been set too far or too close.

the lenses in the lens mount properly. In this space of time the subject must at least remain in the measuring field and at the same distance, otherwise the Minolta 7000 cannot catch up with the measuring and can only establish that it cannot establish anything.

### Subjects with intersecting parts at different distances

That the auto-focus computer is very efficient is beyond doubt, but it is a computer which obeys a programme. This programme tells it to focus on whatever appears in the measuring field. If that happens to be the bars of a lion's cage, then it focuses on the bars, even if your intent was to photograph the lion. If, however, the lion and the bars appear according to TV presentation convention (meaning: balanced), then the computer doesn't quite know what to make of it and refuses to go on working.

I dislike repeating myself because I am relying on your wonderful memory, but in this case I shall do so intentionally.

All the examples which were mentioned just now make up only a tiny proportion of all photos. Even if you take your

Minolta beyond the limits of the auto-focus you should not throw your lens in where all the other sponges are already lying. There are different possibilities for getting a picture after all. Only one thing is impossible: to get a blurred picture with an automatic. The Minolta 7000 always shows you if it cannot help you with its auto-focus if one of these rare occasions should occur, but it does not stop there. In order that blurred pictures do not even insult your eyes, the AF-computer simply blocks the shutter release – no focus, no photo, that's it. (If you have set your heart on a blurred picture, you can use the following technique in a way in which it was not intended to be used. The delayed-action shutter release can be used even when sharp pictures are not to be expected).

You have already been told of one possibility for establishing the focus. The focus memory is activated by a light touch on the shutter release button. Let us imagine that your friend in a white dress is standing very close to a white wall in the bright sunlight of the Aegean. Your Minolta 7000 gets into quite a state because of the lack of contrast and the enormous brightness. In such a case you can put your mind at rest and measure the blue shutter in front of the whitewash and by this you can then store the established distance. Because a small aperture setting is needed due to the bright light, the large depth of field will bridge the difference.

You can leave the automatic system out completely and focus manually. You either rely on the AF-indication in the viewfinder or focus with your own eyes. The focusing screen which is included in the Minolta 7000 series does not offer any focusing aids. You have to focus on the focusing screen, which thanks to the bright micro-honey-combed surface should not present a problem.

If you belong to the more timid sort who would rather be completely sure, you can attach a focusing screen with a micro-prism ring and split-image rangefinder to your Minolta.

A third possibility for getting sharp pictures in the event of

The viewfinder display of the Minolta 7000 gives information about the automatic focusing and also helps the photographer during manual focusing. If it cannot obtain automatic focusing, the Minolta 7000 indicates this by flashing LEDs.

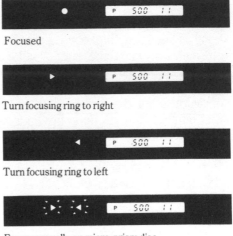

Focused

Turn focusing ring to right

Turn focusing ring to left

Focus manually on micro-prism disc

your AF-computer being on strike, because of the lack of light, is to use Program Flash 2800 AF, which has a second, red reflector, apart from the normal flash reflector which you know from other flash guns. This red reflector projects a red grid onto the subject (which must not be more than 5m away) and the auto-focus computer is able to distinguish between sharp and blurred with the help of this grid. Problems when working with this "red flash" present themselves if the focal length of the lens is longer than 50 mm and if the subject is without contrast, but very bright. In these cases you are not able to use this solution. The bright light simply overwhelms the red grid.

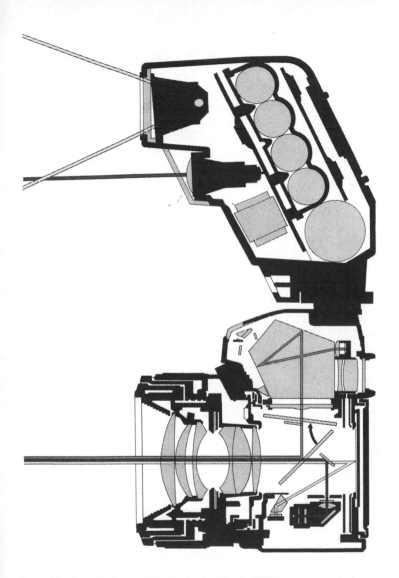

In combination with the special flash units the Minolta 7000 becomes an auto-focus camera which can be used at any time. A second reflector, situated underneath the main flash, projects a red pattern onto the subject (which must not be more than 5m away) and this pattern provides the auto-focus system inside the camera with the "contrast" it needs for focusing.

## Where DO The Blurred Pictures Come From?

It is most annoying if one day you find amongst your pictures some which are not quite satisfactory as far as their sharpness is concerned, although the camera had signalled its consent to the setting (and that must have included the focus). Before you rush off to the shop-keeper with righteous indignation about your faulty Minolta, you need to consider a few more facts, but I shall not mention them until later because I do not want to put the cart before the horse.

# Description of the Minolta 7000

Even if the Minolta 7000 should be your first single lens reflex camera, you must have seen a few of your friends' cameras, or those of tourists at places of interest. If you think back to those cameras, you will notice that the Minolta 7000 looks quite a lot different. This is not surprising! The Minolta 7000 not only belongs to a completely new generation as far as technology is concerned, but it is also a product of the future rather than of the present in its design.

Naturally the Minolta 7000 is not the only 35 mm camera which has adjusted to the computer age in appearance, and it is also not the first one to do without knobs and levers and offer keys instead for its operation. The thing with the screen has also been seen before, but who gets upset by that? The engineers and designers at Minolta consistently worked for improvement and produced a camera which is right all round. Whether you think it is aesthetically pleasing or just practical is a matter of taste, and I would not want to influence anybody. The Minolta 7000 was not built for a beauty contest, but for being used in the hands of a photographer, and in this respect it has a functional beauty.

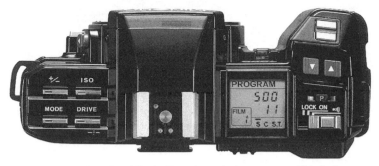

A look at the top-plate of the Minolta 7000 shows the large screen which displays all important data. In this case the automatic programme has been set and it has selected ¹/₅₀₀sec. and f/11. The first picture has been exposed; the motor is set to single pictures, which is signalled by the dash above the "S" (single).

## Television in your Camera

What one notices at first is the "screen" on top of the right-hand side. This is an LCD field (Liquid Crystal Display, which use up less electricity than LED's – Light Emitting Diodes), on which all the important photographic data are made visible. In other words the results appear in letters or numbers and not as a pointer which moves across a scale.

The screen is divided into four zones. The uppermost zone shows which type of exposure reading is being used. You can see the following:

● "PROGRAM" for programme mode
● "A" for aperture priority
● "M" for manual exposure adjustment
● "S" for shutter priority

You will find out in later chapters what these different kinds of exposure controls are all about.

The middle zone of the display serves to show shutter speeds and apertures. That which you have set is always marked by an arrow. The film speed is also displayed in this sector, either during setting or on request.

41

The frame number can be seen in a little field at the bottom on the left. In another little field on the right of this one the setting of the motor is indicated by the letters "S" and "C". S means "single" takes and C means "continuous" ones. Finally, the letters "S.T." stand for "self timer".

Just as the film speed is only displayed when required, so is the aperture correction factor: a plus or minus sign to jog your memory. When a key is pressed the reading is shown in numbers so that you are able to re-set or check.

That is not all you can read from the display: flashing readings give the additional information that:

●    The desired aperture/speed combination is not available (shutter speed and aperture are flashing)

●    The required shutter speed is not available, meaning you are warned about possible over- or under-exposure (shutter speed flashes)

●    The required aperture is not available – also warning of over- or under- exposure (the aperture indicator flashes)

●    The battery power is near its end and only a few more pictures can be taken (all indicators are flashing). The wise man, especially when he is travelling, plans ahead and purchases at least one set of replacement batteries.

●    The built-in lithium-battery, which supplies the camera with power when all others have failed to do so, is exhausted. The life span of the lithium battery is given as 10 years by Minolta and by then you will have forgotten all about what it means if the frame number and the film speed indicators are both flashing.

These are not all the readings you can see moving across the little screen. If there is nothing to be seen, apart from the letters "S", "C" and "S.T.", which have been printed on the screen, then it means that no batteries have been inserted, or that the inserted batteries are completely without power. If the indicator field in the middle is blank, and no shutter speed or aperture values are shown, then the camera is switched off. If instead of the aperture, two dashes

("– –") are to be seen on the display, this means that the exposure meter is activated, but there is no lens on the camera.

Finally the display also gives information about count-down times on the self-timer, namely the remaining time up to shutter release. Instead of the frame number you will be able to see in the small square field the numbers being counted from 10 to 1. In this field the seconds will be counted downwards if a delayed exposure has been set.

Malicious gossip has it that there is only a TV game missing in order to make full use of the little screen, but the 7000 photographer completely ignores that.

## Many Keys to the Goal

Where knobs, levers, tiny knobs and tiny levers used to wait to be set, on the Minolta 7000 touch-sensitive keys are eagerly awaiting your pointed index finger so that they can be pressed singly or in combination and thence give orders to the camera controls.

If one ignores the shutter- and lens-lock keys, which are familiar from earlier models, then there are eleven new keys whose functions should become second nature to you.

A central field with four rather narrow silver-coloured keys is on the left of the viewfinder prism. These keys can only be used sensibly together with the blue ones, which are situated above the camera grip. With these you are able to determine which settings you want to change, but you must then press the blue buttons in order to do so. This is just the same as if you were to put a remote-control car onto a certain track and then determine with the blue keys whether it is to go forwards or backwards to its fixed stops.

The "+/-" sign is for the correction factor; "ISO" stands for the film speed; "MODE" simply means that you can choose the exposure control, and finally "DRIVE" gives you the choice between single, continuous or self-timer shots.

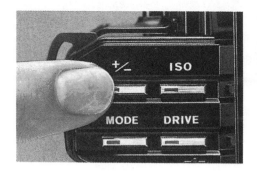

Depressing one of the four silver-coloured keys selects which camera function is to be altered by the blue keys on the right hand side of the viewfinder prism.

As I said, you can choose what you want to alter with these four keys and then with the blue keys on the right carry out the settings.

The two blue keys have no writing on them, but are marked with arrows instead. The one pointing to the front is used when you want to steer your remote-control car forward along the track, and the one pointing to the rear is for driving backwards. Their use is meaningful only in connection with keys '' + /-'' and ''ISO''; this is because the tracks to be used for ''MODE'' and ''DRIVE'' are circular tracks. You pass all the various stations which are of interest to you again and again whichever way you go round.

There are three inconspicuous little keys, one marked with ''P'' (left of the LCD display), one with ''AEL'' (top right on the back of the camera) and one with ''R'' (also at the top on the back, but moved more towards the middle).

''P'' means ''program'' and this key is misleadingly known as the ''programme retrieving key''. This is quite true; no matter whether you have set aperture priority, manual exposure adjustment or shutter speed priority, as soon as you press this button the programme mode is restored. Not only this, it also re-sets any other set correction factor back to zero and the motor function goes back to single-frame mode. At the same time the course of a self-timed or long exposure is interrupted. Key ''P'', therefore, over-rides everything and returns the camera to

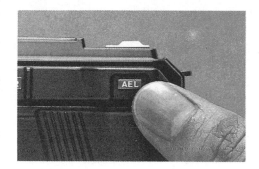

"AEL" stands for "Auto Exposure Lock". The exposure data (speed and aperture) are stored until release.

its base settings. Only the film speed remains at the value you have set.

"AEL" stands for "automatic exposure lock". It is used when the important part of your picture does not lie at the centre of the frame and you want to make sure that it is correctly exposed. You first meter on that crucial section, press the "AEL" key to store the exposure value, and then reframe the picture to your satisfaction and press the shutter release. (As I have mentioned before we shall encounter all these subjects at some point in the book).

Finally, "R" means "rewind". With this key and a slide switch to its left, you can make the motor of your Minolta 7000 transport the exposed film back into the cassette.

## Three Old Acquaintances

If you have held a Minolta in your hands already, you will surely have recognised the three controls which I am going to introduce to you now.

The shutter release, which is situated on the sloping top front edge of the hand grip, has been designed in the tried and tested "touch switch" form. It is not at all necessary to press the shutter release even lightly in order to activate the camera. It is sufficient just to place your finger on it. Because the skin is slightly moist it is enough to close the electrical circuit. What will happen, you are asking now, if one's skin is very dry, or if one wears gloves because the temperature is below zero? In this case the camera can be activated by lightly pressing the shutter release. The story of the touch-sensitive shutter release is interesting, but only of minor significance among the features that add up to the overall impression made by the Minolta 7000. Much more important is that the first pressure point can be felt quite distinctly – the shutter release has to be pressed down this far in order to make the automatic distance reading work (and to store the measured distance, but you know that already).

The main switch is also situated on the top right hand side of the Minolta 7000, a sliding switch with three stop positions. They are "LOCK" (the camera is switched off completely), "ON" (the camera can be released by the shutter) and "○)))". With the switch in this last position the camera can be activated by the shutter release and then in certain situations it will make a bleeping noise; they are 1) if focusing has been achieved, 2) if the film is at its end, 3) while the selftimer is running, 4) if the shutter speed is too slow for the camera to be held by hand, which occurs for different speeds according to focal length of lens fitted.

Because the light metering system of the Minolta 7000 switches itself off after 10 seconds, if the camera has not been activated, the position "LOCK" is of interest only if the camera is not to be used for a long period of time, which I

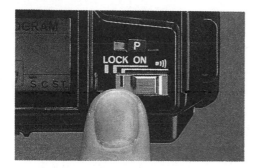

The main switch turns the camera on ("ON") or off ("LOCK") and it is also used for activating or de-activating certain acoustic signals ("○)))")

would find difficult to imagine, or if there should be the danger of some object constantly pressing on the shutter release and thus causing a drain on your batteries, such as if your photography bag is overloaded.

The last key which has to be mentioned is the lens unlocking key. It is situated on the left half way up the lens side and has to be pressed to remove the lens from the bayonet. Another sliding switch is situated underneath the unlocking key with the positions "AF" and "M". As you will quite correctly assume this is the reversing switch for selecting automatic or manual focusing.

As I have already briefly mentioned, the concept of touch sensitive keys is not to be spurned; nobody would really expect a pocket calculator to have a dial by which the numbers had to be entered. If one uses the pocket calculator as a comparison, they really should have spent more time on the keyboards. Keys have to have a certain minimum size in order to be "user-friendly". Even with bare hands you can get into trouble with the keys of your Minolta 7000; for example, if you want to switch quickly from aperture priority to manual setting. But, as with any new machine, you should practise using the controls, before you put any film in the camera, until you are thoroughly familiar with them. Then you should have no problems.

However, we are not able to change anything, we just have to accept the keys as they are and try to make the most of it.

This means thinking in good time which function is needed in order to set it in peace and quiet and without wearing gloves.

One advantage of the keys must not be hidden though: it is almost impossible to make an incorrect judgement.

## Good Contacts

A camera like your Minolta 7000 is not a lone wolf but stands in the centre of a big pack. It is invited to a photographic expedition from time to time and is then supposed to find its partners. The flash guns are part of the pack. They slide into the hotshoe of the Minolta 7000 and establish contact with the camera by one of four contacts. The large contact in the middle of the clip is important for all types of flash guns which are tailored to this middle contact, and there are only a few which do not have this fitting. The other 3 contacts are for flash units which can be integrated with the camera electronics and are able to exchange information and commands with it. The novelty is that the red flash is fired in advance for automatic focusing without your having to set anything.

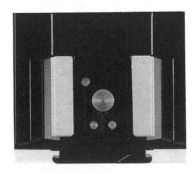

The accessory shoe of the Minolta 7000. The large contact in the middle fires any flash unit that is equipped with the relevant matching contact. The other contacts are provided for special flash functions such as automatic setting of the synchronisation speed or automatic TTL flash.

Further contacts hide behind a cap on the left front edge of the Minolta 7000. The remote control is attached here. Four more contacts in a strip in the camera base are for making connection to the Control Grip 1000. We shall return to these contacts, which are waiting for their opposite numbers on the accessories, when we have finished our tour round the camera.

## For Power and Security

The base of the Minolta 7000 does not contain any setting controls, apart from the contacts I have mentioned and the tripod bush. This is sunk in beneath the lens axis and takes the normal quarter-inch tripod screw.

The batteries have been hidden in the camera hand grip, which makes work with this camera very comfortable. The battery compartment can be removed completely from the grip, and for once the fastening screw can actually be undone with your bare fingers. The coin-slit still exists, but you do not have to hunt around for small change in all available pockets in order to change your batteries.

So far I have kept quiet about one particular button, but it fits into this section so well that I did not want to mention it previously. It is positioned in the lower third of the right-hand end of the Minolta 7000 and is used to open the back. I think this is the right moment to mention this button because we shall now look at the inside of your camera.

The battery compartment can be removed from the camera for loading by undoing a screw (without a coin!). Four AAA size batteries are used but if the larger AA size is preferred, the BH-70L housing will be needed.

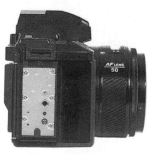

# The Film Compartment

As soon as you have opened up the back you will first notice the film gate, which is closed by one of the two shutter curtains. Don't let anything but your satisfied eye rest on the shutter, because otherwise harm would come to it and you would have to do without your Minolta 7000 while it is being repaired. To the left of the film gate is a compartment into which a two-pronged fork protrudes. This is where the film cassette goes and which, by means of six double contacts, automatically conveys information about the film to the camera and thence via nine contacts under the film gate sets up the connections to the data- and control-backs.

Two shiny strips are situated above and below the film gate. These are the film guide rails which, together with the film pressure plate on the back, have the job of keeping the film flat. After all, the film was kept wound for months in its cassette before you interrupted its peace and it wouldn't mind keeping this curved posture. In the interest of the greatest possible sharpness, however, this cannot be allowed.

The right-hand side of the interior is taken up by a thick roller and a pivot with sprocket wheels at the top and bottom. Both of these pull the film from its cassette and roll it up.

After looking at the back, we shall now have a quick look into the camera from the front, for which purpose we have removed the lens.

The bayonet ring, made from high grade steel which has been impregnated with a lubricant, has a slightly unusual feature. This is the clutch which allows the AF-motor inside the body to focus the lens. Five contacts lie immediately behind the bayonet on the top. These maintain the information flow between camera and lens. They are

*Above: The use of a wide angle lens gives an increased effect of depth by the steep perspective. Photo: Gerhard Klaus*
*Below: Artificial light lends a yellow-red tint to a day-light film, but it seems pleasant and friendly and only rarely does one need to eliminate it by a blue filter. Photo: Werner Schäfer*

*Above: The inside of a church, flooded with light, is characterised by lots of little windows. Photo: Martin Dreymüller*
*Below: A boring facade is changed into a delightful subject because of the view through the gap in the roof. One is looking straight up and accepts the converging verticals. Photo: Alfred Röwemeier*

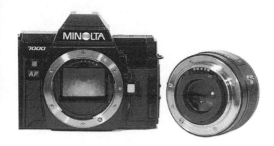

Contacts for data transfer in the camera and lens bayonets. The auto-focus motor focuses the lens by "crankshaft".

situated just to the left of the aperture transfer lever.

(A little note here: when your camera lies in front of you, the lever will, of course, be on your right. So that you and I shall not always have to think whether we should look at the camera from the front or from an angle at the left onto the top, I shall give you the left and right directions always in relation to the direction in which the camera is pointed, which means looking at the camera from the back. If you always look at the front of the camera, because you feel very pleased with it, you will never produce any good pictures).

The aperture transfer lever connects with a lever in the lens bayonet by means of which it opens up the diaphragm of the lens completely while the lens is being attached. From this you will quite correctly conclude that the aperture of the lens which has just been removed has closed to its smallest value.

Only when a picture is taken does the aperture transfer lever give way and allow the diaphragm to stop down if a setting has been given to it either by the exposure control or by you.

In the centre of the space behind the bayonet is suspended the instant-return mirror, which is adorned by a pattern. If

Insertion of films is very easy. The film leader does not even have to be "fumbled" into a slit in the film take-up spool. When using the new DX-coded films it is not even necessary to set the film speed; the camera reads it from the metal strip on the film cartridge and feeds it automatically into the exposure control. The film speed can be checked in the display. The film speed may also be set by hand, even for DX-coded films when the manual setting overrides the automatic one. The motor transports the film automatically to the first frame when the back is closed (it also operates if the camera has been opened and no film has been inserted).

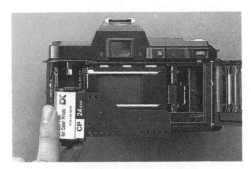

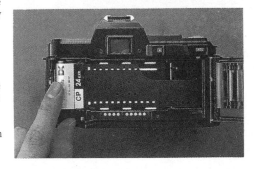

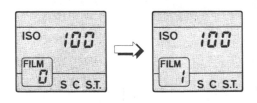

Rewinding is not done automatically at the end of a film but has to be activated: the time while the motor is working can be used to look for a new film.

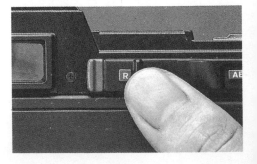

54

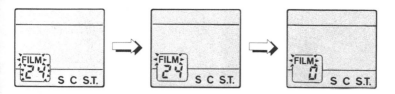

The last frame number flashes on the monitor during the motorised re-winding.
The motor will stop when the last frame (or rather, the first frame) has
disappeared into the cassette, and the frame counter will then move to "O". The
film disappears completely into the cassette; a small disadvantage if you develop
your own work.

you think back to your first look through the view finder you
might remember that you didn't see this pattern at all, and
that is a good thing otherwise it might distract too much from
the subject. The pattern shows those parts of the mirror
which are translucent. At this point a portion of the light
coming from the lens is diverted to the twin separator lenses,
which you will remember from the chapter about the auto-
focus mechanism of your Minolta 7000.

The mirror should be treated with exactly the same
respect as the shutter curtain. If any dust or fluff has been
deposited on the mirror you can remove it by blowing it away
with your blow-brush, or in an emergency remove it with the
soft and clean hairs of this brush, but under no circumstances
with any coarser materials. Pressurised air from a can, which
is recommended for cleaning the outside, must not be used
here either. What could possibly happen, you ask? The
mirror could be put slightly out of alignment so that the rays of
light would be reflected at a different angle to that intended
and the Minolta 7000 would focus where it shouldn't.

In the base of the mirror chamber can be seen a cavity. The
receiver for the light reflected by the film for the TTL-flash
reading hides down there (we will come to it later) and in a
second cavity (which can only be seen when you look into the
mirror chamber from the back or if the mirror has been
raised) lies the receiver for the AF-reading.

Now that I have introduced your Minolta 7000 to you in great detail from inside and out – with the exception of the red LED between the grip and bayonet, which indicates the self-timer count-down by flashing – we shall now briefly turn to the view finder.

## Clear and Informative

The picture in the viewfinder of your Minolta 7000 is not disturbed by any indicators, and because even the focusing aids have been omitted from the focusing screen there is nothing at all to distract you from the subject. Nevertheless, you are still informed by the viewfinder about everything that is important to you. For this purpose, a small LCD-strip is situated along the bottom edge of the viewfinder. This indicates the shutter speed, the aperture and the mode of exposure control, which can also be read on the big display on the camera, as well as warnings that the measuring range of the light meter has been exceeded.

With the help of the upward and downward pointing arrows it is also possible to achieve the correct exposure in manual setting mode, but the self-timer count-down and the extended exposure are not shown – there would be no point anyway.

Next to the LCD-strip the focusing range is indicated by two red LED arrows and one green LED dot. If the left arrow lights up, then too large a distance has been set, if the right arrow lights up the distance has been set too short. The green dot indicates correct focusing. At the same time the arrows show the direction in which the focusing ring has to be turned in order to attain optimum sharpness manually.

Between the AF-indicator and the display you also receive information from a red flash symbol, if you are working with the appropriate flash guns, about the availability of flash and correct flash exposure.

Your introduction to the Minolta 7000 has now been completed with the viewfinder – it now only remains to have a look at the lenses.

## Of One Piece

You already know that the Minolta auto-focus lenses are equipped with only a very rudimentary focusing ring and are totally without an aperture ring. What else is notable about this new lens series? It is that they have been fitted with a ROM (Read Only Memory) chip in which all the important data are embedded; for example, type of lens, aperture sequence, focal length, and, with zoom lenses, effective aperture.

The distance, which is usually set automatically and only very rarely manually, is shown in a window on the upper part of the lens. Left and right of the index is the depth of field scale for fixed focal length lenses, from which you can read how large the depth of field will be for certain apertures. The infrared index is included within this scale, whereas it appears as the only additional information for zoom lenses – divided for the different main focal lengths of the variable lens.

The ring for manual distance setting lies right in the front of the lens, with the exception of two of the twelve lenses of the initial series. Operation of this ring is easy because of its milled edge. All zoom lenses have been designed as two-ring or rotating zoom lenses, for which the focal length is set with a wide ring, which is easy to grip, and the longest focal length will always be set by turning to the right.

The lens bayonet does not offer any interesting features; it simply shows the counterparts for the transfer and coupling elements which we got to know in the camera bayonet.

## All in All

The Minolta 7000, judging by everything we have seen so far, is a camera of the latest generation with all the mod. cons. a photographer could possibly desire. Certainly the keys could be larger, but this complaint does not weigh heavily if one takes into account all the other advantages. One of them is especially important: the Minolta 7000 fits beautifully into one's hand, thanks to the hand grip and the thumb impression on the back, and all the operating controls are where they are needed, instead of having to be searched for.

# The Agony of Choosing the Right Film

Even with a camera like the Minolta 7000, which is stuffed full with all this modern technology, one of its most important functions has nothing to do with technology for it is to serve as a light-tight container for a film; after all, without a film there can be no photography. Certainly one can sit down and be terribly pleased about the fact that the camera can focus by itself, and how it manages to do it, and how the indicators change under different conditions, but it is high time that something to look at is produced. For that you need a film. The only question is which one? I don't mean that you have to decide on a certain brand, but on a certain type of film. You can choose between black-and-white film or colour film, between slide film or colour negative film.

The question of whether to use colour or black-and-white is of fundamental importance, because if you want to take black-and-white photographs you will need to see differently from someone who prefers to photograph in colour. If you want to capture your surroundings without the addition of colours it is much easier to do everything yourself, from taking the photo to making the finished print.

# In Praise of Shades of Grey

For years black-and-white used to be the only way to take photographs. To reproduce the world in its natural colours was a dream which many people believed to be in the realm of Utopia.

Black-and-white pictures depend on the contrast between light and dark, and they must reveal the structure of the subject which has to be recognised even in the absence of colour.

A continuous scale of grey shades extends between the extremes of white and black, but they will only appear in a perfectly finished print and that is (nearly) never done for you today. Surely there must be labs which print black-and-white pictures by hand, but they are much harder to find than colour labs.

Therefore one should start one's own darkroom, which need not be excessively expensive. The processes can easily be managed by a novice so one can soon proudly show off the results to the family, after all they have had to do without the photographer for hours because of the pictures. They have also had to do without that important room, which is small enough to be darkened quickly, has running water available, and where it does not matter if a drop of developer is spilt because it is tiled thoughout anyway. Let us call a spade a spade: as long as the darkroom is being used the bathroom is out of bounds.

Soon even the more complicated work of black-and-white photography will be able to be done relatively easily: selective shading of those parts of the picture which are too dark and spot-printing of those parts of the picture where hardly any detail can be seen. Oh yes, black-and-white photography today is print photography (apart from very few exceptions).

If you decide upon black-and-white, it is a choice with far-reaching effects which you will enjoy tremendously,

*Black-and-white photography demands of the photographer that he be able to see colours in shades of grey. Looking through a colour filter may help. Photos: Gerold Kohlberger (above) Roland Pilz (below)*

provided you have an eye for black-and-white and grey intermediate shades. To decide on black-and-white photography can be compared to an artist who uses a pencil instead of watercolours.

## Colour Prints or Colour Slides

As mentioned before, the material on which the image is captured for the black-and-white photographer is usually negative film. There are not many choices for deciding differently.

It is different if you decide upon a coloured picture of the world, because then you have to choose between colour-print and colour-slide film. Before you choose, you should know what it is all about (just as in politics, it would not be bad at all if one knew beforehand what to expect from the election victors).

Colour print films (as with black-and-white films) form a negative as the link between shot and final picture. On the negative all brightness readings have been reversed: dark parts of the subject are recorded as light and light ones as dark, so that a snowman appears as a black figure in a black space. To make it more difficult, with colour-print films the colour renderings are reversed: the colours of the subject appear on the negative in complementary colours; therefore the blue sky above the snowman appears as yellow. That is it would appear yellow, but even that is not correct because the whole film area is covered by a coloured mask which is needed for better colour separation. You can see that a black-and-white negative can be either too light (under-exposed) or too dark (over-exposed), on a colour negative even the colouring can be out of balance.

You will have seen the statement that an under-exposed negative is too light. It will be projected on to photographic paper on enlarging, and that again forms a negative, a negative of a negative, so everything that was dark on the subject, but light on the negative, will be dark in the final

picture. If the whole picture was under-exposed, and therefore too dark, the whole negative has to have been too light. Logical? Logical! If everything works all right all the colours will appear to be realistic on enlarging, but you have to find a proper processing lab, because it is not all that easy to enlarge from a colour negative yourself, and quite a bit more expensive than from a black-and-white negative.

A proper processing lab – are there any improper ones then?

All the large colour labs, to which your film will be sent to be developed so that you can see your first prints, are equipped with large and expensive printers which enlarge automatically. They have been calibrated for certain basic parameters, and even have programmes for exceptional circumstances, but they are nevertheless automatic photographic machines and are unable, like any other machine, to override their programmes. Thus pictures with dominating colours are (often) treated as ones with a colour fault; pictures which have been under- or over-exposed on purpose are treated according to their apparent handicap and you will not be able to see any of the effort you have put in to create an individual interpretation.

Quite apart from the fact that the basic setting of the printer is often not altogether correct, there can be other maladjustments so that, for instance, all pictures appear with a purple tint, as if they had accidentally dropped into raspberry juice. You can always complain about such photos and perhaps you will prefer the green tint on the next lot, because you prefer lime juice to raspberry juice. All this sounds very nasty, but if you take normal pictures with a normal distribution of colours and brightness values, and if you want a few photos of the family gathering, then you are quite safe with a large lab. The printer is set for normal pictures, and as long as Uncle Fred recognises himself on the photo with Auntie Mabel, then he won't be too upset about a slight tint.

If, however, optimum colour reproduction matters to you,

then the only thing that remains is to set up your own colour lab, or else you have to reach for a slide film.

Your own darkroom is most certainly a wonderful thing to have – if you are willing to invest some money, if you are prepared to tackle the problems of colour theory, and if you take care to observe strictly the processing times and temperatures and become really familiar with the materials. Perhaps you may have the opportunity to look at a friend's darkroom before you decide, and perhaps you can even watch him at work.

The decision to go for colour slide film is a lot easier. What is the difference between a slide film, also known as reversal film, and a print film? The negative, which lives its own separate life with print film, is reversed on a slide film into a positive image during development. As a result you receive a slide in which the light subjects are light and the red ones are red. However, this slide is exactly the same size as a black-and-white or colour negative and in the case of the 35 mm Minolta 7000 measures 24 x 36 mm. Black-and-white and colour negatives are enlarged on photographic paper so that they can be looked at and enjoyed; the slide is normally thrown onto a screen with the help of a prjector and can then be appreciated in all its glowing colours and brightness.

I wrote "normally" because in your own darkroom, as well as in a commercial lab, prints of very good quality can be produced from slides. In both cases the slide has got an advantage over the negative in that you can immediately compare it with the print and nobody can tell you that the colour tint is a fault in the negative and could not be filtered out. If the slide is all right, then so should be the picture, except that slide film is able to reproduce much greater contrast differences that the colour print. On a slide the fall of the folds of a white blouse can be seen just as well as the crease of black trousers. On a colour print either the blouse will be a white area, or the trousers a black one, because colour prints cannot differentiate well enough. In order to get an impression in advance of the picture which awaits you, you

can hold the slide against a white, evenly illuminated surface. What you can now see on your slide will be seen on the print as well. What you are able to see on projection in the enlarger will only be on the print if the contrast range of the slide film has not been fully exploited.

## Slide Film the Favourite

One thing is clear to me: if you have a keen eye for graphic detail and would like to decide on everything yourself, then you should reach for a black-and-white film and equip a small black-and-white darkroom.

If you want to capture all the colours of your surroundings, then the colour slide film is the best photographic medium. It gives you superb sharpness, and one cannot fault the colour reproduction. It is more a matter of taste as to which manufacturer of slide films you favour, because some emphasise the ''warm'' colours, whilst others tend more towards ''cold'' colour reproduction. If someone tries to tell you that the erection of the screen and the setting up of the projector spoils all the fun of slides, then you should reply that: firstly you can take copies of the best slides for your album, and secondly that there is no photograph which can be compared with a projected slide 3 ft or more across.

## Special Films for Special Purposes

The choice of special films is larger than you might think because photography is not just a pleasant hobby but is also an essential tool in scientific and technical work. For example: you might have noticed when you last went skiing that the bones of an adult are not as elastic as those of a child, and after your little accident the doctor was able to help you so efficiently because there are x-ray films, but you will never need them yourself (unless you happen to be a doctor). But we do not want to talk about this sort of film but about the ones you can load into your Minolta 7000.

Firstly I can mention a variation of the slide film which is little known. This is artificial-light slide film, which has been balanced to suit work with photographic lamps and tungsten light, whereas the "normal" slide film is balanced for daylight.

Infra-red film has also been tailored to a special sort of light, the invisible infra-red light which adjoins the lower red end of the visible spectrum. There are infra-red films for black-and-white reproduction and for colour films. The colour film of this type, especially if used in connection with colour filters, promises the most spectacular results – pictures which attract our attention, spectacular green skies and pink meadows, for example.

By the way, infra-red light has got a peculiarity which is important for focusing with IR black-and-white films: it is refracted to a different extent than visible light by the lens and therefore focuses on a different spot. Consequently if you leave the setting completely to your Minolta 7000 and its auto-focus system you will obtain blurred pictures. If you just think back to the introduction to the auto-focus lenses you will remember that the "infra-red index" was mentioned, which hides in the depth-of-field scale of fixed focal length lenses and is the only additional information given on zoom lenses, apart from the focus index. If you have a zoom lens in front of you, you can see that the infra-red index for the

*Black-and-white infra-red film is a special film which is not commonly used. When this film is in the camera the focusing distance, which will have been set automatically, has to be re-set manually on the infra-red index on the lens. IR film makes winter-like pictures possible during summer time, however the use of a red filter is essential. The single-colour filters of the Minolta filter range can be used on the AF lenses without misleading the automatic system. Photos: Reinhard Lehmeier (above)Felix Nacovsky (below)*

shortest focal length is further away from the normal stop than the one for the longest focal length. That means that the aberration of the infra-red rays is more pronounced for shorter focal lengths than for longer ones.

In practice, in order to achieve sharp infra-red pictures, you have to do the following: let the Minolta do the focusing first, as you are used to, then move the small switch at the bottom left next to the bayonet from ''AF'' to ''M'' and manually transfer the distance, which was determined by the camera, to the infra-red index. Now you can safely release.

Another tip for handling infra-red films: if a film is developed later than the indicated date it could be spoilt and the colours might be reproduced incorrectly. Normally if a film is kept in the fridge, and that should be the habit, the expiry date can be exceeded slightly, but this does not apply to infra-red film! It is essential to keep this film in the fridge and it has to be developed immediately.

A third category of special films are the three instant picture films which Polaroid offers for 35 mm cameras. One of them is a colour slide film, and two are black-and-white slide films, of which one is very suitable as half-tone film for normal black-and-white photography, with the difference that slides are produced, and the other one as line film, which tries to reduce the subject to black-and-white and can be used for reproduction and documentation. The instant slide films do not produce single pictures immediately, as one is used to with other instant films, but instead the whole film is developed after exposure in a special machine and it can be shown a few minutes after the last shot. If speed is most important, then the colour and black-and-white half-tone film is definitely worth considering. Let's say you are at a wedding, then the newly wed couple could be presented on the evening of their wedding with a slide series showing the glittering event.

# All about Film Speed

Film needs light in order to reproduce an image. Should it not get enough light no image is captured; should it get too much light then the image is burnt out.

But not all films need the same amount of light. Some are very happy with just a little and nevertheless capture a subject, whereas others rely on a lot of light. Depending on how much light a film needs, one categorises it by a certain "film speed". One differentiates between the slow films, which need a lot of light, the very fast ones and the extremely fast ones, which manage with very little light indeed.

In order to make an exact gradation possible, speed scales were introduced, two of which are still of interest to the Western world. One is called "ASA" after the "American Standards Association" and the other one "DIN" after the "Deutsche Industrie Norm". The "ASA" values are widely used all over the Western hemisphere whereas the "DIN" values are used in German-speaking countries. In the states of the Eastern Bloc film speed is defined as "GOST".

One thing, however, is common to all systems. A film which is one stop faster than another one needs half the amount of light to achieve the same result. A film which is one stop slower needs twice the light. One also says that the film which is one stop faster is twice as fast as the original material; the one which is one stop slower is half as fast.

For ASA films, the speed which is twice as high is indicated by a figure which is twice as high, half the speed accordingly by a figure half as high. In order to use the same example as before, the standard speed this time is a film of ASA 100. The film which manages with only half that amount of light and is

*Above: The atmosphere produced by the light of the setting sun is represented beautifully in the clouds: the reflection of the old facades is very effective because of the "warm light". Photo: Bernd Hartmann*
*Below: The special attraction of this picture lies in the dull colours relieved by the green sail which serves as a counterpoint.*
*Photo: Hans-Jürgen Vermehren*

*Above: The composition of the picture in pastel colours is enhanced by the soft-focus filter effect, which lends the picture a romantic ambience.*
*Photo: Maya Heizmann*
*Below: Vignetting, normally unwelcome as an aberration, can be used deliberately to intensify the picture's expression. Photo: Ulrich Tholl*

therefore twice as fast is the ASA 200 film. The ASA 50 film will need twice as much light as the ASA 100 film; it is half as fast as the ASA 100 film and only a quarter as fast as the ASA 200 film.

For the DIN system, the gradation is calculated on a logarithmic basis, the individual speed ratings are increased by the difference of 3. For example: if as standard we take a film with film speed of 21 DIN, the film which is twice as fast is the one of 24 DIN (3 DIN values higher), it manages with half the amount of light. The film which is half as fast is the 18 DIN film, which needs twice as much light as the 21 film. It follows from this that the 24 DIN film is four times as fast as the 18 DIN film.

Because you have to feed your Minolta 7000 with ASA values, I shall only give ASA values from now on. In any case the one and only large German film manufacturer has now changed its film descriptions in order to align them with the ASA values. But for readers who might be used to the DIN system I have included a comparison table on page 73.

In this table I have marked all the values which you will meet more often with an asterisk. The other values are of interest to you if you want to influence the automatic exposure control of your Minolta 7000 via the film speed.

ASA and DIN speeds as such are now obsolete. ISO (International Standards Organisation) speeds are now recognised by nearly every country in the world. They are written thus:— ISO 100/21°. The speed numbers are identical in every way with the older ASA and DIN figures. Only the names have changed.

The double nature of ISO speeds can be explained quite simply. The number before the oblique stroke is the speed expressed arithmetically. Double the number means an increase of speed by a factor of 2. Halving the number means half the speed.

The number with the degree sign following the oblique stroke is the same film speed but on a logarithmic basis just like the earlier DIN numbers. The degree sign is merely to indicate that the number it accompanies is a logarithmic speed. The earliest DIN speeds carried a degree sign but this was dropped subsequently.

It must be emphasised that the change from ASA and DIN speed numbers to the current ISO figures does not mean any change at all in the methods used in the laboratory for evaluating emulsion speeds.

Films of different speed are not simply there to fill the shelves of shop keepers. One can easily imagine why there are extremely fast 1600 films, which are 16 times as fast as 100 film which nowadays is regarded as standard film. When the light fades one can still carry on taking pictures with this film without the use of flash, and if one has a slow lens on the camera an extremely fast film helps to compensate for its limitations.

What applications are there for low speed films? Firstly there are hardly any low-speed films available. If one inserts an ASA 25 film it is because one wants to achieve the ultimate sharpness. Film speed is produced by silver crystals in the emulsion layer and the larger they are, the more sensitive, i.e. fast, is the film. From ASA 200 these crystals become visible as grain and adversely influence the sharpness. If every tiniest bit of sharpness is of importance, then the low speed film is best suited. (The film by itself is not good enough, though, as one also needs a tripod for shots like that so that every little movement of the camera is eliminated during picture taking).

At the present time films of ASA 100 and ASA 200 are normally recommended for daily use. Low-speed films and fast ones are the specialities for rare occasions.

35 mm films can be purchased in 4 different sizes: with 12, 20, 24 and 36 exposures; there is only one black-and-white film with 72 exposures; the HP 5 autowinder film by Ilford. It

| | |
|---|---|
| Slow films:<br>ISO 6/9°<br>ISO 12/12°<br>ISO 25/15° | ISO 320/26°<br>ISO 400/27°<br>ISO 500/28°<br>ISO 640/29°<br>ISO 800/30° |
| Normal films:<br>ISO 50/18°<br>ISO 64/19°<br>ISO 80/20°<br>ISO 100/21°<br>ISO 125/22° | Extremely fast films:<br>ISO 1000/31°<br>ISO 1250/32°<br>ISO 1600/33°<br>ISO 2000/34°<br>ISO 2500/35°<br>ISO 3200/36°<br>ISO 4000/37°<br>ISO 5000/38°<br>ISO 6400/39° |
| Fast films:<br>ISO 160/23°<br>ISO 200/24°<br>ISO 250/25° | |

is especially useful for reportage when it is very difficult to change the film and it is, as the name suggests, only used for shots with a motorized winder.

You should always reach for films with 36 exposures, unless the number of exposures is limited for some reason, nothing is more annoying than to stand in front of a beautiful subject and not have any film available. Good films are certainly not given away, but you should always expose the last few frames and have the film developed. Exposed films as well as unexposed films are sensitive to warmth, and it would be a pity if the pictures which have been taken suffer because of mistaken thriftiness.

# The Shutter

Your Minolta 7000 belongs to the group of 35 mm single reflex cameras with an electronically controlled focal plane or slit shutter. Most probably you are now asking what a slit is supposed to shut, or vice-versa, why a closed slit is of such importance for a camera. Well, all this is meant differently.

The film must not be exposed to the light continuously, but only for a certain carefully measured time. At all other times the the shutter prevents light from reaching the film. Its other function is to allow the light access to the film for a certain period of time, and how that is done is explained by its name.

A focal plane, or slit shutter, comprises two curtains, in the case of the Minolta 7000 these curtains consist of metal blades. One of the curtains covers the film gate whilst the other one is waiting to be brought in, meanwhile its blades are stowed one behind the other.

The pressure on the shutter release button is the starting signal for the sequence of events for the shutter. The first curtain, which covered the film gate, is accelerated rapidly and opens the film gate. At the same time the count-down begins for the second curtain, which also starts rapidly after the time set, either by you or by the automatic control, and then closes the film gate.

If the shutter speed is longer than $1/100$ second, the first curtain will reach its destination before the second one starts. However, should the shutter speed be shorter, then a slit is formed between the two curtains and this races past the film gate, the shorter the time the narrower the slit that races across the frame. This is where the name of "slit shutter" originates.

How much time elapses between the starting points of both shutter curtains is determined either by the electronics, when a continuous range between 30 seconds and $1/2000$ second is available, or you can determine the time yourself

*Even fast moving subjects can be reproduced very sharply with extremely short exposure times, such as the ¹/₂₀₀₀ sec. of the Minolta. In addition an awful lot of luck is needed to release the shutter just at the right moment, as in this picture by Lone E. Nissen.*

and then all the steps in the same range are at your disposal as well.

To these must also be added ¹/₁₀₀ second as synchronisation speed and "bulb".

What complete steps can be set? The shutter speed scale has been standardised internationally and is based upon doubling and halving.

Each shutter speed allows the light to react with the film for twice as long as the next shortest speed and half as long as the next longer one. The shutter speeds on your Minolta 7000 LCD display are indicated as follows (on manual or on shutter priority settings): 2000, 1000, 500, 250, 125, 100, 60, 30, 15, 8, 4, 2, 1'', 2'', 4'', 8'', 15'', 30''. Two things should be noted: "2000" does not at all mean 2000 seconds, and the "4" does not mean four seconds. Only the numbers with the '' are whole seconds. For all other gradations the 1 above the

fraction line and the line itself have been omitted for simplicity's sake. Therefore the "2000" stands for $1/2000$ second, and what the "4" stands for is not difficult to guess now either.

Shutter speed is only one of the factors which decide how much light is allowed to get through to the film. The other factor is the aperture, which has nothing to do with the camera but is situated in the lens. I shall deal with the aperture in the next chapter.

# The Aperture

Whereas the focal plane shutter governs the duration of the exposure of the film, the aperure determines the amount of light reaching the film in a unit of time. The principle of the aperture is quite simple. It consists of several blades which are pulled apart on opening and produce a more or less round larger or smaller hole in the middle. Because the shutter speeds have been arranged in orderly steps it is not surprising that the aperture openings also follow the principle of halving and doubling. It follows that each numbered aperture opening lets in twice as much light as the next smaller one and half as much as the next larger one.

Logically, if one starts at aperture f/1, then one might expect aperture f/2 to let in twice as much light and aperture f/4 twice as much again. That may seem logical but is totally, totally wrong. What rules govern the aperture scale then?

The diameter of the aperture hole could be measured in millimetres, but there would be one difficulty connected with that. A hole of the same diameter would allow more light to get to the film with a short focal length lens than for a long focal length one. This would mean that different calculations would have to be made for every lens, although the apertures would be the same – and that must be avoided.

Therefore another idea appeared: one does not measure an aperture by its diameter, but puts this into relation to the focal length. If the diameter is 12.5mm and the focal length 50mm, then the relation is 1:4, one can omit the ''1'' and talk about aperture 4. The number, 4 in this case, is also talked of as the ''f'' number and the aperture is then f/4. At aperture f/4, the same amount of light should get to the film, no matter what the focal length of the lens. So far so good, nothing simpler than that! Thus we can arrive at a universal scale, based on f/numbers, to measure apertures regardless of focal length.

To be exact, the aperture we are concerned with is not the real diameter of the aperture opening but the so-called

"entrance pupil". That is the aperture hole as enlarged by the lens elements which lie in front of it. You can see the entrance pupil if you look into one of your lenses from the front. Because the whole thing is complicated enough anyway, we shall leave this excursion on the subject of the entrance pupil at that and will in future talk about the diameter of the aperture opening.

Because the "1" is omitted from the description, one arrives at the strange mathematics of photographers, for f/5.6 is larger than f/8 or f/11. The aperture sequence reads: f/1; f/1.4; f/2; f/2.8; f/4; f/5.6; f/8; f/11; f/16; f/22; f/32.

If you remember the statement that every aperture is either letting in twice or half as much light as the one next to it, then you will presume that the sequence just mentioned has been arranged with half steps because it would seem quite logical that aperture f/2 is twice as big as f/4. But that is quite wrong.

The aperture sequence does indeed show the whole values. Thus f/2.8 is twice as large as f/4 and not twice as large as f/5.6. How can that happen? Let's look at an example, in which we shall omit the entrance pupil as we said and will only work with the aperture diameter! The aperture diameters of a lens of 50 mm focal length are:

$$50 \, mm : 2.8 \; = \; 17.86 \, mm$$
$$50 \, mm : 4 \quad = \; 12.6 \;\; mm$$
$$50 \, mm : 5.6 \; = \quad 8.93 \, mm$$

Therefore the aperture diameter for an aperture of f/5.6 is twice as large as for f/2.8. That's right. But the light does not come through a small slit along the diameter, but through an approximately circular area, and then the whole matter looks different. The well-known quantity of $\pi$ turns up, which we shall round up to 3.14 as we have learnt at school. The areas of the aperture openings are given by the formula: area $\pi \, x \, r^2$ (where r is half the diameter) becomes:

$$\text{f}/2.8 \ : \ 8.93 \times 8.93 \times 3.14 = 250.4$$
$$\text{f}/4 \quad : \ 6.30 \times 6.30 \times 3.14 = 125$$
$$\text{f}/5.6 \ : \ 4.46 \times 4.46 \times 3.14 = 62.5$$

These (rounded up) figures demonstrate that aperture f/4 does indeed allow twice as much light to get through the opening as aperture f/2.8, and that for aperture f/5.6, whose opening diameter is twice as large as f/2.8, four times the amount of light gets through to the film. The doubling of the area is achieved by an increase in the diameter by times $\sqrt{2}$. The aperture stops increase accordingly by the factor $\sqrt{2}$.

Not all apertures fit this standard however. The largest aperture openings deviate from it. Whereas the diameter which the aperture blades expose on the standard aperture scale is chosen so that the correct amount of light reaches the film, the largest aperture opening simply complies with the maximum possible opening which the lens can offer. This is how it can happen that the largest aperture may be f/1.7 or f/3.5, as is the case for instance with one of the normal lenses of your Minolta 7000 or with zoom lenses.

By the way, one not only talks of the "largest aperture", but also of the "largest relative opening" or, most commonly, of "speed". As far as speed is concerned the zoom lenses present you with a riddle. After all, the same aperture opening, as briefly mentioned already, allows more light to get to the film at shorter focal lengths than it does at longer ones.

Because the focal length can be altered on zoom lenses you might think that if the diameter of the aperture opening remained the same, the aperture would decrease (f/number increase) as the focal length increased, and in proportion to focal length. But it doesn't, as we shall see in the following example.

If we look at the lenses of the Minolta with this in mind, we discover that the 70-210mm lens has a largest relative

opening over the whole range of f/4 and that there is a maximum difference of one aperture stop between the speeds at shortest and longest focal length. That can be explained by the phenomenon of the entrance pupil because a few elements in their sub-mount are shifted within the lens for the alteration of focal length. The factor which optically enlarges the aperture hole is changed too, and this factor enables a bigger reduction in the amount of light to be avoided. If we want to reduce the loss of light to zero, i.e. the same initial openings apply to all focal lengths, it can be achieved for some types of zoom lenses, but only at the cost of a much more complex design and so we remain content with a speed difference of about one stop.

We have now become acquainted with the third most important factor for the exposure, that is the aperture which controls the amount of light which is allowed to reach the film at any shutter speed. The others were the shutter speed and the film speed. How do these interact? Beautifully, which the next chapter will show.

## Doubling and Halving Complement each other

Three series which have been constructed according to the principle of halving and doubling must have been designed to act in combination, and indeed they do. Let us assume that light falls on an ASA 100 film in order to produce the correct exposure at $^1/_{125}$ second and aperture setting f/4. Let us assume further that for this or that reason, which we shall go into in the chapter about picture creation, this stop/speed combination is not to your liking. If you should prefer aperture f/11, then it will not present a problem in achieving the right exposure. Only one eighth of the amount of light reaches the film at f/11 than can pass at f/4, therefore this amount of light has to be able to react eight times as long with the film. Instead of $^1/_{125}$ second, $^1/_{15}$ second is now the correct time.

Naturally there are other combinations also which (as far as the exposure is concerned) achieve the same result as $^1/_{125}$ second with aperture f/4 or $^1/_{15}$ second with aperture f/11. If the lens has a largest relative opening of f/1.4 and a smallest aperture of f/22, then the stop/speed combinations, which all result in the same exposure would be:

| Aperture | Speed | Aperture | Speed |
|----------|-------|----------|-------|
| f/1.4 | $^1/_{1000}$ | f/8 | $^1/_{30}$ |
| f/2 | $^1/_{500}$ | f/11 | $^1/_{15}$ |
| f/2.8 | $^1/_{250}$ | f/16 | $^1/_8$ |
| f/4 | $^1/_{125}$ | f/22 | $^1/_4$ |
| f/5.6 | $^1/_{60}$ | | |

A term is used for these stop/speed combinations, it is "light value", which should really be called "exposure value" and is often known by this name. In order not to confuse you too much, I shall use the term exposure value, which is usually abbreviated to EV. The sequence which I have detailed above comes under the name of EV11. EV12 begins with aperture f/1.4 and $^1/_{2000}$ second and offers $^1/_8$ second at aperture f/22, whilst its other neighbour, EV10, couples aperture f/1.4 with $^1/_{500}$ second and aperture f/22 with $^1/_2$ a second.

Because you have been paying attention you know that all this only works out if the third quantity of the group remains unchanged. That means the film speed must remain the same because if EV11 was correct for an ASA 100 film, then the same stop/speed combinations with an ASA 400 film would result in pictures which were over-exposed by two stops, as long as the brightness remained the same. Before we concern ourselves with the brightness, just briefly something else: just look at the pairs which form EV11! You will see that you cannot take a photograph with $^1/_{2000}$ second at EV11 because none of the Minolta AF lenses has got the largest opening of f/1, and that longer times than $^1/_4$ second

are unavailable, provided everything remains within the framework of normal conditions.

It could of course become necessary, perhaps because of extreme extension in the macro-range, or because of the use of light reducing filters, to set your camera at a whole second at aperture f/22.

# Exposure

The film which you have chosen for your photos needs a certain amount of light to produce a correctly exposed negative or slide. Shutter speed and aperture control the quantity of light. This amount can be a little more or less for a print film because it does not object to these deviations, thanks to its relatively large tolerance. The situation is different for slide films. They have a high sensitivity to too much or too little light and require an exact exposure. Well and good, but how are you to know how much light your film needs?

## Exposure Reading: How Light is it Outside?

Exactly how much light your film needs is available in tables, but you do not have to bother about these. What is much more important for you is how light your subject is. In order to find this out exposure meters were invented. The simplest one is the selenium exposure meter which converts incoming light into electricity which can then be measured. As one cannot do anything with selenium exposure meters once it gets dark, cadmium sulphide was used as the light-sensitive material. It does not produce electricity when light falls upon it, but changes its electrical resistance instead. This change can be measured; all one needs is a measuring circuit. However, one has to rely on batteries or accumulators and, although CdS cells are better than selenium ones, they do react rather slowly in the dark.

Manufacturers hunted for a better light-sensitive material

and found silicon, that element which occurs quite naturally in sand. Pure silicon changes light into electricity as does selenium, but the amount is so low that one can only measure it using amplifying circuits. Therefore the exposure meter with a silicon cell also relies on an outside power source. Your Minolta 7000 is provided with a silicon cell which establishes how bright the light is that is reflected by your subject. For every measuring process one needs a reference point, and this starting point for photography was found in the "ideal subject". The "ideal subject", it was laid down, reflects exactly the same amount of light as a grey card of 18% reflectivity. The exposure meter has been calibrated to this reflectivity.

## What Follows from the Brightness Measurement?

The exposure meter knows the power of the electricity from the silicon element for this run-of-the-mill subject, and it also knows that more electricity means a lighter subject and less a darker subject. The brightness which has been determined is of no use unless we also know the film speed. Now a second combination, apart from the EV, gets into the picture. This is the combination of brightness and film speed. Every film speed has been given a certain number and so has every degree of brightness, and one can combine these numbers. The result is a reading which again can be equated to the EV, and now everything seems clear. Brightness and film speed determine which EV has to be used, and the EV offers a number of stop/speed combinations which will all lead to the correct result.

Is all that very complicated? Well in practice everything is much simpler; not without reason can one obtain cross-coupled exposure meters and the most diverse kinds of automatic exposure cameras. Before we turn to these we shall make a little detour to the effects that shutter speed and aperture have on the picture.

# The Simplest Aid to Creativity

We have already met the phenomenon of depth of field during the subject "auto-focus". You will remember the story with the points which are reproduced as little discs and are still seen as points by the eye.

## Depth of Field – or the Antlered Grandfather

This is not a funny story about a grandfather and his rival in the leading role. This is all about the effects of depth of field, which have nothing to do with sharpness.

Even here I cannot proceed without a preamble. The Minolta 7000 is a camera with open diaphragm metering. No matter which aperture you are going to use for your shot, the aperture will remain open up to the moment of shutter release. Open aperture means the smallest depth of field of the relevant lens. Therefore you cannot establish with your own eyes from which point to which point the depth of field extends. If you want to know this you have to look up a depth of field table, or glance at the depth of field scale of your lens.

As time goes by you will develop a feeling for how far your depth of field will extend, and you will not miss the stop-down lever quite so much – an equipment feature which would not have gone amiss with this well thought out camera.

Now all about the antlered grandfather. I know the story is not new and that such pictures turn up again and again in explanations on the problem of depth of field – but it is so suitable that I do not want to keep it from you.

Just imagine a family get-together, which takes place in a rustically furnished living room. The owner of a camera is not even asked, he is simply announced as the photographer of the festivities and takes photos of all the dear relatives in turn. He also takes Grandad, who has stood up to give a little speech in honour of the birthday child. Our photographer has quite a fast lens of longer focal length (oh yes, you are saying, so shallow depth of field) and he is completely engrossed in

*Depth of field is an important factor in picture creation. Everything was sharply reproduced from front to back in the upper picture because of the small aperture of the wide angle lens. In the lower picture the lens was focused on the chairs; the background is not totally indistinct, but clearly less sharp because of the bigger aperture and a longer focal length lens.*
*Photos: Günther Snattzke (above) Werner König (below)*

85

catching Grandad during his speech, sharp in front of a blurred light background. He is concentrating so much on choosing the right moment for the shot, that he completely forgets to look at his aperture setting. This is set at f/11 because he uses a flash (f/11 – larger depth of field, you are thinking now? You are on the right track!) When Grandad lifts his glass, our photographer presses the shutter release. Let us skip some time now. The pictures have arrived from the processing lab, without colour tint, only cut as usual on the wrong side. Then the great laughter starts. Grandad stands there, raising his glass, and the antlers of a magnificent 16 year-old stag are growing out of his head. The photographer was unable to see the antlers in the background through his viewfinder, because of the narrow depth of field, but because of the large depth of field produced by the actual aperture on taking the picture, it was reproduced (nearly as sharply in focus), as Grandad himself.

The moral of this story: a small depth of field often enables one to emphasise subjects against a blurred background, but one must take care that a wide open aperture is being used.

It is true that open apertures and shallow depths of field are not suitable for every subject. Subjects which stretch far into the distance require a small aperture and a large depth of field; landscapes for instance, or poppies flowering in a wheat field. Architectural photography also calls for a large depth of field and the small apertures associated with it, which of course often means a long shutter speed, but that's another subject.

*Whereas the upper picture is influenced by the steep perspective of the super wide angle lens, the effect of the narrow field of view of the telephoto lens is shown below.*
*Photos: Dieter Matthews (above), Wolfgang Marzinek (below)*

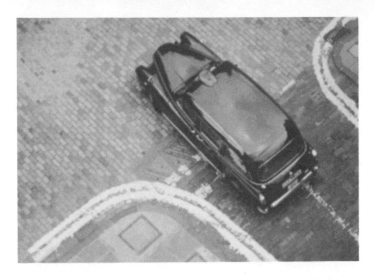

*Above: If viewed from the right angle, an ordinary subject can be made into an interesting one. Photo: Peter Höß*
*Below: Double exposure during slide copying or in the lab makes this seemingly dangerous picture possible, without anybody actually being in danger. Photo: Alfred Schell*

# Blur – or Camera Shake?

Many photographers have been annoyed about blurred pictures and moaned about the "lousy" lens, although neither was the picture out of focus nor the lens lousy.

Blurring can be the result of wrong focusing or inadequate lens performance but is more often caused by camera shake, which is usually due to carelessness or over estimation of one's own capabilities.

Most probably you have tried at one point or another to look at an animal, a bird or a boat through a pair of binoculars. You will have noticed how much your surroundings are jumping up and down in the binoculars. Because your surroundings do not move, all you have seen was the shaking of your own hands. It is exactly the same in photography, but here one has "camera shake factors" which depend on the focal length of the lens.

A wide angle lens embraces a very large part of the surroundings, and the details are reproduced correspondingly small. The double and multiple outlines which result from movement during exposure are also just as small.

The situation is different for a telephoto lens. Compared to the normal or wide angle lens the double outline is enlarged. The longer the focal length, the more plainly visible it becomes, although your hand shook just as little as it did during the wide angle shot.

If you do not believe me, take a torch with a rather wide light beam and try, for example, to keep a light switch on the opposite wall in the middle of the light cone. You will have no problem at all, and you will not realise that the focusing spot is moving with respect to the light switch. If you then partially cover the reflector, so that only a very narrow beam of light falls upon the light switch, you will notice that the point of light is swaying about.

Back to camera shake, or rather how to guard against camera shake. If maximum sharpness is most important to

you, you should invest in a sturdy tripod and take all photos which are of importance to you with the camera on the tripod. Maximum sharpness is only possible in this way. But who wants to lug around a tripod all the time? Although there are many subjects for which one could erect a tripod in peace and quiet, there are probably just as many which do not allow the photographer to do this. Quite apart from this your Minolta 7000 is a fast camera; the auto-focus equipment makes sure of that, and so do the automatic exposure modes and the built-in motorised film winder. All the time you have gained because of these facilities is wasted if you work with a tripod. This should not be taken as a rejection of the tripod, but you have to consider whether the use of this bulky item is worth it for your pictures or not. (If there is a car at your disposal, then the question of the tripod poses no problem. It can lie in the boot and it will be more readily available for you.).

However, even without the supporting aid of such a three-legged friend, you will be able to achieve pictures without camera shake if you observe a few points.

Firstly, the correct hold on the camera is important. The best way is to hold the lens from below with the left hand, this will also put the thumb in the right position for the two buttons which open and close the aperture. The setting ring on zoom lenses for the focal length adjustment can also be operated easily and comfortably. The right hand holds the camera grip so that within reach of the index finger lie the shutter release button, the two setting keys, and the key for the zero position of the camera, while the right thumb can quite easily press the AEL key from behind.

During the shot it is advisable to press the elbows firmly into the body or, if possible, support them on something. The backrest of a park bench is just as suitable as the railings by a footpath. Sideway support should not be dismissed either, a lamppost can be found quite easily. Even if passers-by look at you in a funny way, leave this little bit of enjoyment to them because there is probably nothing for them to laugh at on T.V. anyway.

The most important factor for shots without a tripod or other stable support is the shutter speed, for which there is one rule of thumb:

1/shutter speed = focal length (mm)

When using this formula it is advisable to round up rather than down. Consequently it is better to use $^1/_{250}$ sec. for a 135mm lens than $^1/_{125}$ sec.; for an 85mm lens, rather $^1/_{125}$ sec. than $^1/_{60}$ sec. Above 300mm anything slower than $^1/_{1000}$ sec. should not be considered for hand-held shots.

## With or Without "Wiping Effect"

Shutter speed, therefore, is an important criterion for a sharp picture. Shutter speed is also of interest as a creative tool as soon as movement gets into the picture.

A fast shutter speed captures a brief instant of a movement, and in doing so it freezes the movement. A galloping horse can be captured with $^1/_{1000}$ sec. or even $^1/_{2000}$ sec. as if it was motionless, with all four legs in the air. A racing car can be photographed with $^1/_{2000}$ sec. in such a way as to create the impression that the vehicle is parked, and rushing water can be frozen and motionless. The veils of water cascading over the rim of a fountain are reproduced as crystal-clear foil, falling drops are suspended in mid-air as if they were sparkling crystals.

The opposite effects are caused by slower shutter speeds. Whereas a short time simply has to be set in order to freeze movement, one has to think for how long the shutter has to stay open to achieve some other effect. The duration of the incidence of light on the film also depends on the decision as to whether the camera is kept absolutely still or whether it follows the movement. "Panning" is recommended for all subjects which are to appear more or less sharply, depending on the shutter speed, in front of a very blurred background. As far as the galloping horse is concerned the legs would

*The choice of the correct shutter speed is most important if there is movement in the picture. A slow shutter speed leads to a wiping effect, which can be increased by zooming during exposure....*

show the "wiping" effect most clearly, whereas the body and head would be reproduced more sharply. In the case of the racing car the blurred background plainly gives the impression of speed, whilst the car itself is sharply defined. The camera can remain static however when pictures of water are taken because a slower shutter speed reproduces it in a blurred manner. On the other hand a very slow shutter speed (you should use a tripod) makes it appear as a cotton-wool-like substance, comparable with very dense fog, running from the clearly defined fountain rim, or finding its way between the clearly defined banks of the stream.

Panning is a technique which needs to be practised because the viewfinder is dark at the moment of the shot and you cannot see what you are aiming at. It is recommended that you follow the subject with the camera for some time before the shot and keep it in the target field of the automatic focusing area. Make an approximate focus beforehand on a nearby object by a light pressure on the shutter release button. At the point of release the subject has to be in the centre of the frame because focus is being established at that moment. If the racing car is supposed to appear in one corner of the picture, then you have to focus manually and release at the right moment.

## Programme Mode – You Only Have to Press the Release Button

I have only included the chapter on the easiest means of picture creation because you should know what influence the shutter speed and the aperture have on the picture, because it is of no relevance for the correct exposure (within a given EV) what speed and what aperture you set. You can decide according to your idea of the picture and then choose either the manual setting or the shutter or aperture priority modes, you will get acquainted with these in the next chapter. You could also rely totally on the camera and leave it to choose from the suitable combinations which are available.

## Programme – According to the Lens

In the last chapter we have seen what influence the shutter speed has on the sharpness of a picture. Camera shake must be avoided at all costs. Your Minolta 7000 does what it can and sets a suitable programme according to the focal length of the lens.

When using wide angle lenses there is no great danger that your fidgety hand will have negative effects upon the picture. Your Minolta 7000 knows from the data, which the lens transmits to the camera, that you have fitted a wide angle lens and it chooses according to the EV, matching brightness

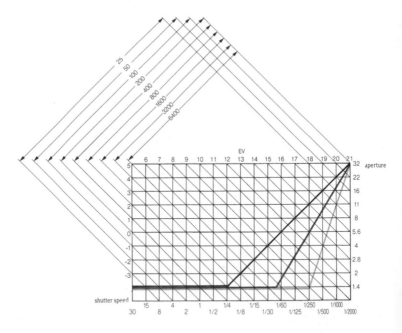

The sequence of the programme changes according to the focal length (which is transferred by the ROM-IC of a lens in the camera) in favour of a possibly larger depth of field (small aperture takes precedence: left-hand line) or in favour of safeguarding against camera shake (fast shutter speed takes precedence: right-hand line).

94

and film speed, a combination with a smaller aperture and a longer shutter speed.

For example with a 28mm f/2.8 wide angle and an ASA 100 film in the camera, the programme sequence looks like this:- at great brightness the camera sets f/22 and $^1/_{2000}$ sec.; if it becomes slightly darker, it sets f/22 and $^1/_{1000}$ sec.; and from then on the larger apertures are approached slowly. At f/16, $^1/_{500}$ is selected, at f/11, $^1/_{250}$ sec., until complete opening is reached at f/2.8 and shutter speed of $^1/_{15}$ sec. The slowest speed for hand holding, $^1/_{30}$ sec., will be coupled with aperture f/4. Because a larger aperture than f/2.8 cannot be set for this lens, the aperture remains the same from $^1/_{15}$ sec. and the shutter speed is extended as the light is reduced.

The story is quite different for the standard programme. We are again looking at the case of an ASA 100 film in the camera with the 50mm f/1.4 standard lens. The provision has been built into the programme that it will not allow the danger

**Wide-angle-programme (with AF 28mm f/2.8; ISO 100/21°)**

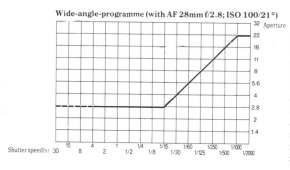

If the programme should give a large depth of field, and is used for focal lengths under 35mm, open aperture is obtained at $^1/_{15}$ sec. This speed is just about manageable without a tripod.

of camera shake (however this will be greater than for the wide angle) and that small apertures for very great depth of field are also not so important as with a wide angle.

Accordingly the graph drops more steeply than it does for the wide angle, here too the case of greatest brightness is met by aperture f/22 and $^1/_{2000}$ sec. The aperture f/11, however, is set at $^1/_{500}$ sec. (approximately, because the automatic programme does not worry about shutter speed

The standard programme is valid for the focal lengths between 35 and 135mm.

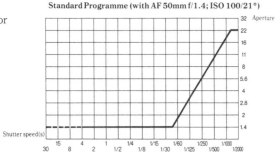

Standard Programme (with AF 50mm f/1.4; ISO 100/21°)

steps, but also selects intermediate readings). Aperture f/2.8 is obtained at $^1/_{125}$ sec. in the standard programme, and the limit of camera shake of $^1/_{60}$ sec. with the fully open aperture f/1.4. From then on there is no alternative but for the programme to select the longer shutter speeds.

After the wide angle and standard programmes you are now expecting a telephoto programme, and you will not be disappointed by your Minolta 7000. As you quite correctly assume, the exposure control of the camera now attaches importance to the high speeds, in order to avoid the danger of camera shake, and opens up the aperture more quickly. This is in spite of the fact that the depth of field, which is not very great for telephoto lenses anyway, diminishes quickly.

The programme looks like this for the 300mm f/2.8 telephoto lens. Again $^1/_{2000}$ sec. is combined with aperture f/22, but f/2.8 is already attained at $^1/_{500}$ sec., although the same brightness on an ASA 100 film would also lead to the correct result at f/5.6 and $^1/_{125}$ sec. But with $^1/_{500}$ sec. the likelihood of camera shake would not be as high as at $^1/_{125}$ sec.

To reduce this to a common denominator, one could say that the programmes have been balanced in such a way that the maximum aperture is obtained at the shutter speed which is valid as the hand-held limit for the relevant lenses and from then on shutter speeds get slower with a fully open aperture. This was a wise decision by the engineers.

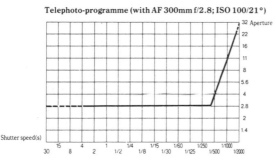

Telephoto-programme (with AF 300mm f/2.8; ISO 100/21°)

The programme to guard against camera shake reacts to less light by opening the aperture, until it is not possible to do so any further. At this point the "safe" speed for the 300mm lens of very nearly $^1/_{500}$ sec. has been almost reached.

Even more wonderful is the fact that you do not have to worry about the correct programme. Your Minolta 7000 finds out the focal length from the lens and takes care of the suitable programme, and this is not only for fixed focal lengths. The exposure control of the Minolta 7000 even notices if the focal length of a zoom lens changes from one range to another (the limits are 35 mm down and 105 mm up) and reacts with the relevant programme.

## Programme – Depending on the Subject

The subject bell has not been invented yet, and even if it had I would advise against a camera with such a thing. All the aids which the technology of the Minolta 7000 can offer are there so that you can concentrate on the subject, and that is what makes photography such a fascinating hobby. The heading of this chapter therefore does not mean that your Minolta 7000 can recognise the subject and then set the correct programme: it is left to you to capture the subject.

The three programmes of the Minolta 7000 are extremely helpful, and in their layout they are also very user-friendly. The majority of all shots will fit into this programme scheme and will not only be exposed properly, but will also be ''correct'' in the matters of depth of field and movement-arresting shutter speed.

However, there will also be situations, despite your wide angle, when fast shutter speeds will be more important to you than a small aperture. You don't have to select another programme in this case only to see your subject disappear because it is fed up waiting. You simply make use of the amenities of the EV. If, let's assume, your Minolta 7000 is of the opinion that the combination of $^1/_{125}$ sec. and aperture f/8 would suit the 28mm f/2.8 wide angle attached, the ASA 100 film and the subject brightness best, then the same exposure can be obtained with another stop/speed combination, of which some combine faster shutter speeds with larger apertures. Instead of f/8 and $^1/_{125}$ sec. these are:

f/5.6  $^1/_{250}$
f/4  $^1/_{500}$
f/2.8  $^1/_{1000}$

If you now press the right-hand setting key behind the shutter release button, the stop/speed combination is moved by one stop along the EV scale. It moves another stop at the next pressure, and so on. Because the aperture, as well as the shutter speed, are indicated in the viewfinder you are able to react in a flash and choose the more suitable speed without having to leave the "programme mode". Minolta calls this choice "programme shift" and the fact that you are using it is shown by the flashing of the operating mode indicator in the viewfinder and in the display. After shutter release it is automatically switched back to that reading which, according to the Minolta 7000, suits the focal length. The change back will also occur if you have intervened in the programme but have not released the shutter after 10 seconds.

It is also possible to raise the shutter speed contrary to the camera's automatic decision; you are then, of course, able to stop down in order to enlarge the depth of field of a telephoto lens. Therefore, with the 300mm f/2.8 lens, aperture f/8 at $^1/_{60}$ sec. could be chosen instead of f/2.8 at 1.500 sec. This is only sensible if you are able to support the camera during the shot, otherwise you will definitely get a blurred picture.

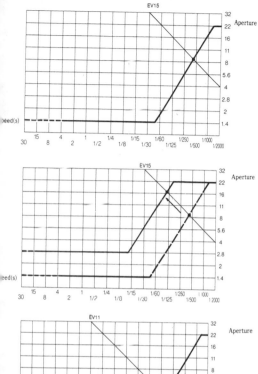

The photographer does not always agree to the aperture/speed combination which the camera sets for him in the automatic programme mode. As the same exposure can be obtained with different aperture/speed combinations, the Minolta 7000 offers the facility of altering the combination within the exposure value.

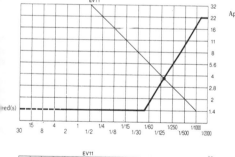

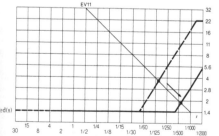

Alternatively, the programme can be changed in favour of a fast speed if movement needs to be frozen. The larger aperture (in the example f/2 instead of f/4) however gives a narrower depth of field, an effect which unfortunately cannot be judged in the viewfinder of the Minolta 7000.

## Aperture According to your Wish – Speed According to your Wish

About a dozen years ago photo enthusiasts were quarrelling. Whereas one side swore by shutter speed priority, in which one pre-selects shutter speed, the other wouldn't hear of anything being said against aperture priority, where one fixes the aperture. A third group thought that every kind of automatic was completely superfluous and was convinced that manual setting of speed and aperture was the only proper way to take photographs.

The XD-7 from Minolta settled the quarrel once and for all. The XD-7 offered both kinds of automatic working, as well as manual setting, and with this gave photographers for the first time the opportunity to choose, according to the subject, the optimum mode of automatic exposure control. In order to be able to do that one has to know the advantages each of the three can offer. I am now going to talk about aperture priority mode.

## Choice of Aperture

When you, the photographer, choose the aperture for the camera in aperture priority mode by pressing a key, the shutter speed setting follows automatically. The camera only has to look for and set a suitable shutter speed which the chosen aperture requires for correct exposure. All available apertures can be set at intermediate stops — an advantage over conventional lenses with aperture rings on which it was often impossible to set the intermediate stops at the end of the aperture range. This facility can be a valuable advantage in critical lighting conditions when you might want to bracket your exposures by taking several shots with small aperture differences.

When pre-selecting the aperture you can either use the setting keys behind the release button or the ones on the upper left on the camera bayonet. On a single pressure the

aperture is altered by half a stop. If you leave your finger on the keys the aperture values run through quickly and you have to be quick to release the finger pressure when the desired value is obtained.

Subject brightness does not change in exactly defined steps. If we follow the basic photographic principle of doubling for the correct exposure level, it is understandable that the automatic speed setting does not doggedly follow the standardised shutter speed steps, but is continuous. Despite the mechanical limitations, and bear in mind that operating the shutter curtains means a mass has to be accelerated and brought to a stop again and the shutter curtains do not run without friction, even the irregular speeds can be achieved. Thus for a certain aperture $1/478$ sec. or $1/493$ sec. or any other odd speed might be set.

It is clear from the chapter on the influence of aperture on the picture for which subjects you choose aperture priority. I am relying on your good memory and repeat here only the most important points: from the same position and with the same focal length, a wide aperture gives a narrow depth of field, a smaller aperture gives a larger depth of field. A narrow depth of field makes it possible to highlight a subject against its background, because the background is reproduced as a blurred pattern. A large depth of field is needed for subjects which stretch into the distance and for which the foreground as well as the background is a valuable part of the picture.

# Choice of Shutter Speed

When shutter speed priority is used, the Minolta 7000 has not got an awful lot to say about exposure. According to the film speed, the subject brightness and the pre-selected time it has to choose a suitable aperture and transfer this information to the lens.

Whereas aperture priority is able to graduate exposure very finely (continuous shutter speed control) the smallest difference for shutter speed priority is half an aperture stop. Why can't one do here what was possible there? With aperture priority the shutter speed is controlled electronically and can set off the second shutter curtain after $1/478$ sec. if that is what is required. Aperture is controlled mechanically however. A lever inside the camera moves a certain distance, this in turn shifts a lever in the lens for the same distance, the lever in the lens finally affects the aperture blades, which again have to move a certain amount from their resting position. The mechanical inaccuracies add up: one tenth aperture cannot be set reliably, at least not at an affordable price.

Shutter speed is set by keys at the shutter release or at the bayonet. It can, like the aperture, be altered in single steps or continuously.

Shutter speed has a great influence on possible camera shake. The longer the focal length, the faster should be the shutter speed, if no tripod is used.

Shutter speed adds movement to the picture, or freezes it. High shutter speeds freeze movement and make visible single moments, which cannot be seen with the naked eye. Slower shutter speeds (possibly coupled with panning) convey movement through wiping effects on the moving subject or on the background or both.

# Self Determination

If you want to arrange the exposure completely to your liking, then you can set the speed and the aperture manually. The shutter speed is set by the keys behind the release, and the aperture by the keys on the bayonet.

The Minolta 7000 makes it possible to set the exposure according to your opinion and shows you if your actual setting of the two factors would lead to over or under exposure. This is only done in the viewfinder, not in the display. But (you will please excuse the harsh word) it is nonsense to set the exposure manually and to do so by following the camera's indications. These indications are based upon the work of the exposure meter and you would not obtain a different result if you pre-selected speed and aperture and then let the automatic do its work, except that you are quite a bit slower doing all this by hand.

So what is the option of the manual setting for? Only because it was possible to include it? This could certainly not have been the reason.

Perhaps in your picture you might want to intensify the thundery mood, which has been in the air for days. You have to under-expose significantly on a bright day – and that can be set very well manually. Perhaps you want to photograph a fireworks display and need a slow shutter speed whereas the automatic would select a wide open aperture which would be no good. In both these cases the manual exposure setting can be used sensibly.

There is also the option to set the exposure with a hand-held exposure meter. For instance, when difficult conditions demand this by spot or incident light measurement, or in a studio with a flash exposure meter.

## Everything has been Thought of

Even if you dont't want to have it easy with the programme mode you can comfortably and easily work with the other two exposure modes which allow you to adapt to any subject. However, the automatic system can only work according to pre-set parameters, which the exposure meter provides, that are calibrated to a grey standard subject of 18% reflectivity. What can one do if the subject does not conform to this standard and the automatic system can then only produce incorrect exposures as a prisoner of the programme. You could:
- set a correction factor
- use the automatic exposure lock
- set the shutter speed and aperture to your liking
Everything has been thought of.

# Subjects Which Don't Fit the Scheme

Statistics are a bit tricky. If you go to a restaurant with an acquaintance and eat two steaks in the time in which he devours ten glasses of beer and ten chasers, both of you are, according to statistics, quite inebriated, because it averages out that you have each eaten only one steak, but poured five beers and five chasers down your throat. Likewise when it was established that the average subject reflects as much light as a grey card of 18% reflectivity, this also is only a statistical average. It does indeed fit quite a lot of subjects, but certainly not all of them.

Which subjects deviate from the standard?
- Subjects in which the part which is important to the picture is small, but much lighter or darker than the rest
- Subjects which are very dark or very light over all
Unfortunately Minolta were not able to produce an

*Above: The picture has depth because of the leaves in the foreground. The frame formed by the coloured foliage completes the impression of Autumn mood. Photo: Walter Löffelmann.*
*Below: It is enough to breathe on the front of the lens on cold days in order to achieve pictures full of atmosphere. Vaseline on a UV-filter also gives a hazy effect. Photo: Dr. R. Mezler-Andelberg*

*Above: Because the wicker beach chairs emphasise the lower part of the picture it doesn't matter that the horizon runs through the middle of the frame. A slight over-exposure has avoided the chairs becoming silhouettes in front of the light background. Photo: Josef Ettmüller.*

*Below: The shadows created by the low sun bring life to the otherwise uniform-looking sand. Photo: Peter Legler.*

automatic system for the Minolta 7000 which would be able to recognise such situations and then to initiate the relevant steps, but everything has been done to help you achieve correctly exposed pictures conveniently.

## Against the Light

A situation which occurs quite often and causes disappointment to the photographer is the shot into the light, where a bright light source lies behind the subject. Similar incorrect results are obtained if a small, dark subject is situated in front of a light background.

A typical example for a back-lit situation is the shot of a person in front of the sun which is just above the horizon and is about to sink into the red-tinted sea.

Let us change places with the exposure meter, which knows that a grey card is an average subject! It sees a wide, bright sky, the very bright ball of the sun, a light sea surface, and a tiny human being who stands out against the light background. All in all the exposure meter thinks this is a light subject, and the camera acts accordingly with a small aperture and a rather fast shutter speed, all done with the best of its knowledge and ability. It simply cannot know that this tiny human being is your girl-friend (or perhaps your boy-friend, your husband, your wife) and therefore more important than the background.

So how can you make provision so that your girl-friend (or perhaps..........see above) is still easily recognisable and that the sunset also has its place?

It is important that the silhouette is lighted. That means that you have to over-expose with respect to the exposure which was thought to be correct by the automatic system. This can be done in three different ways with this particular camera:

1) With the automatic exposure lock and a long focus zoom lens. First read the face of your victim with the long focal length, store the reading and reset to the short focal length to

include the surrounding area that you want in the picture.

2) With a single focal length lens you have to get very close to the lady or gentleman of your dreams until her/his image fills the field of the viewfinder, and then proceed as above. The automatic exposure lock key is most suitable for quick use in a single shot.

3) If you want to keep the over-exposure for a whole photographic series you can feed the camera with a fixed correction factor by means of the + /- key and the two setting keys behind the release button. This method has the advantage that you don't have to take a substitute reading for every shot. The exposure has to be more generous for the desired over-exposure; therefore you will feed in a plus-correction with the right-hand setting key, which is possible within a range of up to four aperture stops in half stops. It depends on the situation, of course, as to how far you want to over-expose. The greater the brightness difference between the main subject and the background, and the clearer you want to make the subject stand out, the stronger the correction has to be.

The second advantage of the correction factor is that it alters the relevant exposure which was established for the picture. Therefore when you take photos at a fashion show, during which the girls walk up and down against a very bright background which is large in our picture area, you would be well-advised to use a correction factor of let's say 1.5. Depending upon whether the model wears a lighter or darker piece of clothing, the exposure will change. A manually set stop/speed combination would only give the correct exposure for one lighting situation, but the correction factor is always based upon the actual reading and it does not even over-expose in the case of a light dress, but simply fills in.

*Subjects can easily become silhouettes with back lighting, an effect which can be overcome by slight over-exposure. Large contrasts between light and dark sections of the picture can also lead to wrong settings by the exposure control. However, if light and dark are balanced and add up to a grey value of 18% reflectivity, then everything is all right.*
*Photos: Bernhard Mielich (above) Klaus-Michael Thieme (below)*

## White on Black

The opposite of the back-lit shot is a bright subject in front of a dark background. As an example, once again, we have to use the bride wearing her white dress and standing in front of the black wedding limousine, specially hired for the day. If the shiny black car fills the background and the dainty bride does not counterbalance this, then the exposure meter sees a subject that tends to the dark side, according to the grey card, and the exposure control will use a wider aperture or a longer shutter speed or both, in order to master this dark situation.

The picture will show a dark limousine and a bride who will seem a little too white. Because of the over-exposure of the light parts the dress is shown as a completely white area in which no details can be seen, and the bride is paler around the nose than she was in reality.

Once again you can obtain the correct result with the substitute reading and the automatic exposure lock. Though you don't necessarily read the white dress only, but concentrate on the face for the exposure reading.

If you want to shoot a whole series, you can again choose a correction factor, this time one from the "minus offer", which is also available in half stops up to minus four aperture stops. Because everything is analogous to the plus correction used in back-light shots, I do not intend to bore you with repetitions.

# Black on Black and White on White

The exposure meter cannot quite cope with subjects which are largely very dark or very light because the programmed standard subject always gets in its way.

If the bridegroom and not the white bride is posing in front of the limousine, then the exposure meter blacks out in the real sense of the word and the exposure control tries to compensate for the darkness with a wide aperture, a slow shutter speed, or even both. The result here is a car and a bridegroom, who both look somewhat washed out. The black of the suit and the paint of the car are not full, but appear greyish.

You can only work here with the automatic exposure lock if you choose the light face of the bridegroom as the subject for a substitute reading and include a little black from the surroundings. The picture might be slightly under-exposed, so that the face is well reproduced, but that makes the blacks stand out even more clearly.

Under-exposure is to be recommended anyway if a very dark subject is supposed to appear very dark in the picture itself, and that can be obtained by a minus correction.

So would an over-exposure be the proper means to reproduce a very light subject as light in the picture? Correct! Because, if the exposure meter is reading the white bride in front of the white wedding coach, the camera will close the aperture and choose a short exposure in order to manage the huge amount of light. What the camera considers to be the correct exposure is really an under-exposure. In this case the white of the pictures is reproduced with a grey tint such that the washing powder manufacturers would have a field day.

A substitute reading is best taken on a grey card with 18% reflectivity, which you can buy, or you can read it off the palm of you hand, which does not correspond to the grey card exactly but comes very close to the standard subject. The grey card, or the palm of the hand, must be illuminated by the

same light source as the subject.

Exposure correction is brought about by a plus factor which gives a more substantial exposure. As in the case of the dark subject, it is also valid for the light one that the correction factor should not be fixed too high because otherwise the opposite of the desired result will be achieved - a totally unsuccessful picture. For such shots a technique which is used by many professionals is recommended if you need a picture that is one hundred percent correct. This is the method of making an exposure sequence, which is best done with the manual exposure setting.

## Technique of Bracketing

For difficult subjects especially, such as back lighting, light in front of dark, white on white and black on black, a great deal of experience is necessary if one wants to obtain the correct exposure, unless one works with a hand-held exposure meter and incident light measurement. But who lugs around one of those things all the time?

If you are not completely sure about the right exposure you could first take a look at the suggestion made by the camera and then re-set for manual mode. If you would like to work with a certain shutter/speed or a certain aperture, then you keep the one factor constant and alter the other. Depending upon how uncertain the exposure is, and how urgently you need an optimally exposed picture, make a series of exposures at half stop intervals in the direction of over- of under-exposure. At least one shot will be exactly as it should be. The ones which lie directly next to it are not rejects; you can still use them because duplicate shots can come in useful, especially for dissolve projection or for the sandwich technique.

Perhaps you are wondering why I recommend the manual exposure setting for bracketing when there is the opportunity to use the programme shift and the correction factors, which stretch up to + /- 4 aperture stops.

It is not possible to use the programme shift for the correction which is needed in this case because the exposure remains the same. Aperture and speed are altered contra-rotationally at the same time in the programme shift. For an exposure correction either the aperture or the speed has to be altered. The actual setting of the correction factors is more cumbersome because you take the camera away from your eye after every shot and have to feed in the altered factor by a two-finger technique. When operating by hand you need two fingers for the basic setting only, then keep the camera in front of your eye and alter the speed or aperture by key, just as you prefer.

## The Trick with the Film Speed

Actually the Minolta 7000 has been so well equipped for all emergencies that I wanted to withhold the story of the film speed from you, but perhaps you will be able to use it one day.

We have already established in great detail that film speed is an important part in determining the correct overall exposure. Film speed and brightness are the two factors used in calculating a suitable EV.

If you think a correction is necessary, one which is lower than a whole aperture stop and higher than half an aperture stop, you can go to the film speed setting and alter the ISO value by one or two steps.

The exposure control now thinks it is faced with a film of one- or two-third steps higher or lower and reacts with an altered exposure, in so far as a third-stop can be set, which can be problematic in shutter speed priority mode.

We shall encounter changing the film speed in the next chapter when we talk about preparation for shooting

# Camera Clear for Action!

"Clear for action" the captain shouts in the old pirate films when a buccaneer is sighted and the crew prepare for the chase. You too should prepare everything before you start on your photographic expedition, nothing is worse than being faced with THE subject of a lifetime and not getting a shot in.

In order that your Minolta 7000 can be used at all, you need batteries, a lens and a film.

As far as the power is concerned, I would suggest the larger batteries (type AA) for the power pack, instead of the small power pack for the thin AAA batteries. The Minolta 7000 does not devour power, but the two motors, the exposure meter, the LCD indicators and especially the viewfinder illumination demand their dues. Just an additional note about this subject: if your Minolta is brand-new you will be surprised at how quickly the first set of batteries has been "sucked dry". You may think that the story about the low energy consumption was simply optimistic advertising which did not reflect reality. However, if you consider how often you have had the camera in front of your eye and pressed the release button in order to check the automatic focus on this or that subject and how often you let the motor go for a jog, only to enjoy the fact that sooner or later you will take shots with this picture frequency. The "high" power consumption in the first days or weeks does, therefore, have to be ascribed to your urge to play, rather than to the camera. You don't have to blush now, you are not the only one.

Inserting the batteries proves to be neither better nor worse than with other cameras. Only during cold weather, when fingers are numb or one is wearing gloves, would one prefer a better solution. Here are some tips if you photograph a lot of snow and ice. Firstly there is a power pack which you can put into the pocket and which is connected to the Minolta 7000 by a cable. The advantage is that the batteries remain warm and therefore more efficient. The second possibility is the purchase of a second power

compartment which can be pre-loaded and kept in the trouser pocket. It is quick and easy to change the batteries and during really bitter weather you can keep on changing the power packs and avoid a drop in performance because of the cold. A third possibility is to use re-chargeable Ni-Cads (nickel-cadmium) storage batteries which are worth their money if you take a lot of photos. In order that you do not have to have a compulsory break when the storage batteries are being re-charged, the purchase of three times the number of storage batteries is recommended, together with the relevant charging unit in which the batteries stay for "conservation charge" until they are needed.

Inserting the film is not difficult, even for the person who has normally got two left hands with five thumbs which normally prevent any do-it-yourself job from turning out successfully. The back is opened by pressing the catch and the cartridge is inserted, with the opening upwards, into the cartridge chamber, so that the little fork embraces the bar in the opening. Then all that is left is to pull the film leader to the right as far as the red mark. Before you close the back check that the teeth on the sprocket drum are engaged in the film perforation holes.

If you have bought one of the new films with DX-coding you do not in principle have to worry about the setting of the film speed; this has been read automatically by your Minolta 7000 from the metal strip on the film cassette. So that you can make sure, the set speed is shown on the camera display. If you do not use a DX-coded film you have to set the speed yourself by using the ISO key and the setting keys.

When the back is closed the built-in motor transports the film to its first frame. The trick for getting two more pictures per film by thrifty insertion does not work anymore.

Now back to the "in principle". We have clarified the matter about films and have also established at the same time that films have to be chosen according to individual taste as far as colour reproduction is concerned. The same applies to colour saturation. It is certainly no waste of money, or time, if

you standardise on a film for your Minolta 7000 and to your taste. Insert a film, look for an average subject in which as many colours as possible are present, and add someone to it so that the important skin tones can also be judged. Then take a picture with the film speed which is given, and proceed in third-stops below until you have reached 2 stops under the nominal speed; and also move up in third stops until you have reached 2 stops above the nominal speed. After development you will have thirteen pictures in front of you, one of which corresponds to your exact requirements. You then count which film speed setting this picture was based upon and you use this setting for all photos with this film. The film carries an emulsion number and if possible you should buy ten or twenty films of this number and keep them in your fridge. You know how these films turn out and you will not have to reckon with a surprise.

The correct exposure, of course, will lie only one- or two-third stops away from the standard speed; the other pictures show you the result of the relevant under- and over-exposure, a useful experience for shots with the automatic exposure lock. If you are using professional films the exact film speed will be indicated on the enclosed leaflet and you have to start your test sequence from this point.

If you are a black-and-white photographer, or develop your own work, you can skip this paragraph. But if you take your films to be developed somewhere else, then this paragraph could save the pictures of your holiday. Every year thousands of films get lost in the post or the labs because the photographer has forgotten in the rush to give his correct address, or because the address sticker was not properly attached, or because the envelope had not been closed properly and the cassette container dropped out. You should record your address on one frame, or even perhaps just the registration number of your car. The search team at the post office and in the large labs make all possible efforts to identify these films. Such identification pictures make their work easier, and give you the assurance that your film will

definitely get back to you.

A series to show you how much the setting has to deviate from the given film speed in order to give you the optimum results can only be shot if you have presented your Minolta 7000 with a lens. The attachment of the lens is astonishingly easy; only two things have to be mentioned.

Firstly, always immediately put the two caps which protect your lens against dust into your pocket. It does not matter if it is the left or right trouser pocket or even the shirt pocket. If you have to be quick in changing the lens you will immediately know where to find the caps.

Secondly, gently turn the lens so far, until the release button clicks into position. If you screw it into the bayonet too firmly, because you are frightened of losing the lens (don't worry, that is not possible!), it can happen that the auto-focus clutch does not mesh with its opposite number in the lens and will turn idly.

Which lens you attach to you Minolta 7000 will depend on what you want to photograph. That is what the next chapter is about.

# THE RICH VARIETY OF MINOLTA AF LENSES

The great advantage of a system camera is that the lenses can be interchanged; this enables you to change the focal length, and with that the field of view for a given subject.

Minolta introduced a completely new lens system with its "7000", with an inbuilt ROM chip and without an aperture ring. But you know all that already because the general introduction of the lenses lies behind us. Now before I introduce these lenses to you personally we have to understand some of their basic features, of which we can already tick off the lens speed, the aperture and the depth of field.

## Space-Creating Perspective

Perspective is a difficult subject. There are two opposing schools of thought. The first opinion is that perspective depends on the position of the photographer. The second opinion holds that the perspective of a wide angle lens is different from that of a telephoto.

What is perspective good for anyway? Perspective makes it possible to add spatial depth to a flat picture, representing objects which are further away from the viewer on a smaller scale than the ones which are closer. The rule is that the reduction is proportional to the increase of distance. An object at a certain distance from the observer seems twice as big as an object of the same size twice as far away. Apart from the continuous reduction in size of the objects in the picture with increasing distance, the spatial impression is also given by the narrowing of the perspective lines: they converge at the vanishing point.

The perspective is always the same if the position of the camera is not altered. It does not matter at all whether you attach a wide angle lens or whether you prefer a telephoto

lens. If you cannot imagine this, then all you have to do is to take two shots from the same position, one with the wide angle and one with the telephoto. You then print a section from your telephoto picture, to say 9x13cm, and then make another print from your wide angle photo showing the same section as the telephoto picture and enlarged to the same size.

If you position the two photos next to each other, then the perspective will be the same in both cases, but you can still (most probably) differentiate between them. This is because if you have taken both photos at the same aperture, then the depth of field will be larger on the wide angle one.

If you enlarge both pictures to the same size, the perspective of the two pictures will seem different, leading steeply into the distance with the wide angle shot and flat with the telephoto picture. The reason for this is that our eyes are also little lenses, which convey a perspective picture of the surroundings. We connect this picture with a certain field of view, with a certain picture angle of about 45° and we consider this picture to be ''normal''. A lens between 40 and 60mm focal legth captures the surroundings just like that and that is why the standard lenses for 35 mm cameras have been provided with a focal length of 50 mm.

The wide angle lens captures much more within the picture than we are able to see with the unaided eye; the perspective lines converge towards the vanishing point from a much larger distance and because of that give the impression of a huge expansion of depth.

Because the film size does not alter with the focal length, the increase of picture information on the wide angle picture has to be reproduced smaller than on the shot with the standard lens. The reproduction scale is reduced. This is different for the telephoto shot. Here only a section is photographed when compared with the standard lens, the details are enlarged, but the picture border is situated very close to the vanishing point. Therefore the perspective lines in the picture are very short, the impression of depth gives

way to a flat impression and all individual parts of the subject seem to be bunched together.

There is a second variable of steep and flat perspectives which you are able to exploit with the wide angle lens. Because of the wide picture angle of its short short focal length, you can get in close and still get in all the subject, whereas you would only capture a section of it with your telephoto. You would have to go back further with your telephoto to cover the same amount. With the wide angle an object 2m from the camera will be reproduced twice the size of a similar sized object 4m away. With a telephoto lens on the other hand, the nearer object may be 8m away from the camera so the second one would be 10m, and therefore only one fifth further away. This is the reason why it will be depicted only one fifth and not half the size of the nearer object and the distance between them would look less.

No wonder, you say, because the perspective has actually changed due to the change in position. That is correct, but it is often overlooked and only ascribed to the use of the wide angle lens on the one hand and the telephoto on the other. One forgets that the perspective also changes if both shots were to be taken with a wide angle.

# Reproduction Ratio – the Nearer, the Larger

The reproduction ratio states how much smaller the subject on the negative or slide is reproduced (1:x) or by how much it has been enlarged (x:1). Reproduction at life-size is ratio 1:1, so the area photographed is 24 × 36mm. Reproduction ratios only play a secondary role in picture making as far as some photographers are concerned, because a completely different picture format gives a completely different reproduction scale.

A slide, of course, will be projected to a width of 1.2m or even 2m, and even a paper print of, say 13x18cm, will be larger than a 35mm negative, but these do not allow you to

make a valid statement about the qualities of the camera lens. The size to which the negative is "blown up" is of no importance anyway if the reproduction scale is larger than the original subject because the reproduction is also larger for the same magnification factor. In practice this means that if you photograph a butterfly at a reproduction scale of 1:3, you only have to magnify it 30 times to get a 10 times enlarged reproduction: if you photograph it at a scale of 1:6, then a magnification of 60 times becomes necessary for the same final result. That means that all the faults of the picture are magnified twice as much and the grain, which may not be noticed in the first picture, can exceed the limit on the second one and therefore be seen.

The ratio depends on the focal length and the camera distance. At the same distance from the subject, a longer focal length gives a greater reproduction ratio than a shorter one. The shorter one will have to be moved closer to give a similar reproduction ratio.

For focusing the lens must move further from the film as the distance to the subject becomes shorter, which means that the lens becomes longer – but we have talked about this already.

A very long extension is necessary for shots towards the ratio 1:1, which for many conventional macro-lenses is achieved in two steps: the first extension is contributed by the lens itself with its helical focusing mount. The largest reproduction ratio which can be attained that way is 1:2, a reproduction at half life-size. The further extension up to 1:1 is given by an intermediate ring which is fixed between the camera and lens. Minolta has trodden a new path with its macro-lens for the Minolta 7000 and has achieved with a so-called "Double Floating System" a reproduction ratio of 1:1 without the need for an intermediate ring and with minimal extension.

## Specialities à la Minolta

The "Double Floating System" of its AF-Macro 50mm f/2.8 is not the only "speciality" which Minolta is offering with its new lenses. Neither does the list end with the internal focusing applied to the AF-135mm f/2.8 and to the AF-Apo 300mm f/2.8

The wide angle/telephoto/zoom 28-135mm f/4-4.5 offers rear focusing by which only the rear two lens groups move during focusing. The 35-70mm f/4 zoom incorporates a compound aspheric element, and the AF-Apo 300mm f/2.8 has two elements made from AD glass, which strongly represses lateral and longitudinal aberrations which are typical for long, fast telephoto lenses. The 300 therefore is allowed to carry the term "Apo" in its name, which derives from the term "apochromatic correction".

That the surfaces of the Minolta lenses have been coated, where necessary, is taken for granted. To conclude this section, coated means that extremely thin layers are evaporated onto the lens surface, thus lowering the reflectivity of that surface. This means on the one hand that more light gets to the film, and on the other that less stray light is scattered about. All this increases the brilliance of the picture.

*Above: The contrast between the dull colours and the strong red make this picture. Photo: Axel Broszies*
*Below: The high position of the camera gives a new insight into this ordinary subject. Photo: Robert Dewilde*

*Selecting a small section of the subject has been of benefit to both pictures. The sea-gull has also had a hand in the affair.*
*Photos: Flemming Kastoniegaard (above),*
*Hans-Dieter Falkenstein (below)*

# Banish Stray Light

Stray light is the enemy of quality in a slide or a negative.

Light is reflected from everywhere, not just from the subject. Stray light rays from elsewhere also find their way into the lens where they can only cause harm. To keep this stray light from the lens is the duty of the lens hood, which you might have heard of as ''sun shade'' or ''back light shade''. Both these names are, of course, not incorrect. Back light shade could mean that the hood is only useful for back light, and this is quite wrong, just as the belief nurtured by the term ''sun shade'' that the hood should only be used when there is bright sunlight.

A lens hood should be attached to the lens for every shot, but it must be a suitable one. It is either provided with the lenses for you Minolta 7000 or is built in anyway. These lens hoods have been precisely shaped to the field of view of the lens. They are not too long, because that would lead to vignetting at the edges or borders of the picture, and not too short either, because that would mean that stray light could still get into the lens. They are too short for the zoom lenses at all focal lengths apart from the shortest one. Why? Because otherwise they would be too long for the shortest focal length and vignetting would occur.

The universal rubber hoods which are offered as accessories from different manufacturers would only be of interest to you if you want to bring your lens into action from a moving bus. You can press the rubber lens hood against the window pane, and eliminate all reflections from the window. Because rubber is a flexible material the vibrations of the window would not have a detrimental effect (at a very fast shutter speed). You must, however, focus manually because the AF motor could suffer damage if the movement of the lens was suppressed by pressure on the glass.

# The Shortest of All: AF 20mm f/2.8
# AF 24mm f/2.8

Not really the shortest of all but the shortest of the normal lenses: there is the 16mm Fisheye lens of which more below. At the beginning of the 1970's 24mm was considered an extreme wide-angle lens because the wide picture angle and the very steep perspective were difficult to master. With the advances in optical glasses and lens design, wide-angle lenses have become much more widely available and the typical extreme wide-angle image is now familiar to everybody, in magazine pictures, advertisements, T.V., and cine-films. Once considered solely as a means for helping you out of a tight spot such as an interior, or an architectural shot in cramped conditions, the extreme wide-angle is now a valuable tool for the pictorial landscape photographer. The AF 20mm f/2.8 in particular enables you to produce wide, sweeping pictures when you wish to create deliberate dramatic effects. It is an excellent lens for exaggerating perspective with minimal distortion.

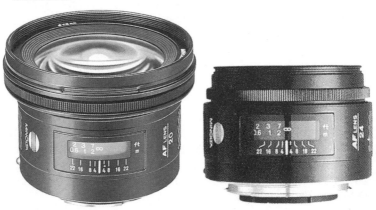

AF 20mm f/2.8 and AF 24mm f/2.8 super wide-angle lenses. Their large angles of view make them very suitable for overall views from which subject details may be picked out with longer lenses.

However, we must not forget the use of these lenses when space indoors or out is confined. The 24mm takes in an angular view of 84° (measured across the diagonal) and the 20mm takes in as much as 94°.

In architectural photography especially, where the location for the shot is often fixed by the building opposite and a wide angle is needed in order to cover the height of the facade, a particular phenomenon must be briefly mentioned. This must not to be blamed on the AF 24mm f/2.8 because it occurs with all lenses: it is the phenomenon of converging verticals.

If a lens is pointed upwards for a picture, then parallel lines running upwards suddenly show an unpleasant tilt. They tilt towards the middle of the picture. The lines run towards each other at the top and a solid skyscraper is changed into one which seems to tilt backwards. This effect is more pronounced the shorter the focal length and the shorter the distance from the subject.

There is no remedy for converging verticals as long as the camera position cannot be raised far enough so that the optical axis of the lens is perpendicular to the facade of the building.

It is not always necessary to avoid converging verticals; the eye also sees these but they are put straight by the brain because we know from experience that converging verticals are a perspective phenomenon and belong to our picture of the world. When applied for deliberate effect, converging verticals show up the height of a building and give the impression of its soaring aloft.

The wide field of view of the 24mm implies also that a large part of the foreground gets into the picture and you have to try to make the most of it. An object which is close to the camera in the foreground lends depth to the picture because it gives the eye something to focus on and makes a comparison of size for similar objects in the background. It is a useful idea to show the foreground slightly blurred; completely blurred would be extremely difficult even for

large apertures. But even the impression of blur is sufficient to fill the space whilst not detracting from the main subject. One way to fill the foreground which is always worth looking at is the vista, such as that through the embrasures of a castle down to the valley, or through a beautiful ornate balustrade of a balcony into the garden.

It would be utterly wrong always to look for a foreground. If the foreground is wide and empty, such as the open space in front of a beautiful town hall, or the desert in front of the palm trees at an oasis, then just leave it empty! But watch out that the reminders of our civilisation (red drink cans, yellow film boxes and white tissues) are not lying around! Unless of course you are planning a report on the environment.

Their closest focusing distance of 25cm might lead us to conclude that these lenses are very suitable for close-ups, but the short focal lengths stand in the way of this opportunity. You will be unable to get anything greater than a reproduction ratio of about 1:10 with this small and light lens. Looking at it another way, however, from this short distance you can still photograph a considerable field of view and also expect a large depth of field, which makes them very suitable for tabletop pictures.

## The Universal Wide Angle Lenses:
## AF 28mm f/2
## AF 28mm f/2.8
## AF 35mm f/1.4
## AF 35mm f/2

A focal length of 35mm was once considered to be normal for a wide-angle lens for a 35mm camera. Many photographers still regard it as such, but with a focal length of about 35mm now being common for the lens in the very popular 35mm compact cameras, and the increasing appreciation of the pictorial effects of extreme wide-angle lenses, 28mm is now generally

regarded as the more universal wide-angle focal length. Quite apart from that, many photographers regard 35mm as better for the standard lens because they find it a more universal general purpose focal length, particularly for candid and journalistic pictures at close quarters. Also the faster 35mm lenses now available, of which the Minolta AF 35mm f/1.4 is a notable example, have greatly increased its scope as the standard lens for a 35mm SLR. Either of these AF 35mm lenses, with their slightly greater depth of field over their 50mm counterparts, are perfect snap-shot lenses for snatching a picture in the most adverse conditions. The AF 35mm f/1.4 is particularly suitable for available-light work of this nature.

With a field of view of 69°, a 28mm lens still takes in considerably more than a 35mm lens, but the perspective does not seem as steep as that of the 24mm. Pictures which have been taken with a 28mm lens do not immediately suggest this wide angle atmosphere.

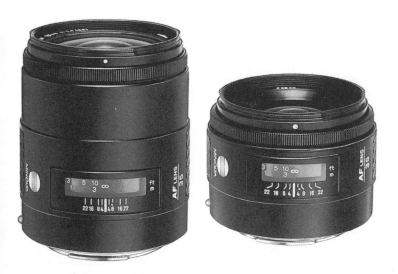

Many people will prefer the AF 35mm f/1.4 or AF 35mm f/2 as their standard lens. The f/1.4 and AF 85mm f/1.4 make an excellent outfit for available-light enthusiasts.

The 28mm is an all-round lens for all situations in which you have to work under restricted conditions, that means also for interior views. You still have to take care that the camera is lined up correctly: converging verticals which occur during shots with a tilted camera are still not as apparent as with the shorter 24mm.

A 28mm should not be omitted from any outfit which is acquired for use in reporting in the widest sense; it enables one to get a total over-all view, which then of course has to be filled out by selected detail taken with a telephoto lens.

If you are mainly interested in snapshots, you may prefer to obtain a 28mm because the snapshot setting allows you to be ready even more quickly than with the fast auto-focus system of the Minolta 7000. Indeed if you want to be very quick with the automatic focusing you have to place the detail which is important for the picture always in the centre of the picture, which can become boring for your viewers, or point at it as quickly as possible (not always easy through the small target field), wait for the lens to focus and then re-compose the picture before you release.

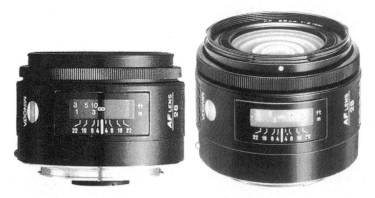

The AF 28mm f/2 and f/2.8 lenses are all-round wide-angles, ideal for the snap-shot photographer (especially the f/2), as well as the photographer of architecture and landscapes.

The snap-shot setting utilizes the large depth of field and the small risk of camera shake which is offered by the 28mm. The unlikelihood of camera shake allows one to pre-select an aperture of f/8 or f/11 in aperture priority mode, because even with $^1/_{30}$ sec. or $^1/_{15}$ sec. relatively good pictures of reasonable sharpness will be obtained. If you have set the distance manually at 5m, then at f/8 the depth of field extends from 1.94m to infinity. It is sufficient with this setting to raise the camera at the right moment and release – you most certainly won't get a blurred picture.

## The All Round View: AF 16mm f/2.8 Fisheye

Fisheye lenses have enjoyed a brief popularity as novelty lenses, but like all novelties their use was overdone and general interest waned. This is a great pity because the Fisheye is a very valuable specialist lens which makes it possible to take otherwise unobtainable photographs. With an angle of view of

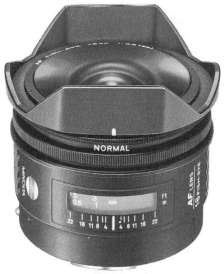

The 16mm f/2.8 Fisheye.

131

180° it can, for instance, cover the whole sky, reaching from horizon to horizon. In fact the first fisheye lens was designed for meteorological purposes. The curvilinear distortion cannot be avoided and the true craftsman of the fisheye uses it to great advantage in generating creative images, particularly in landscape photography. It is possible by very careful alignment, and taking advantage of the fact that straight lines which cross the axis of the lens remain straight in the image, to use the fisheye to produce a picture which does not at first sight look as if such a lens was used. Such shots can demonstrate incredible perspective that is particularly effective with certain landscapes.

## Quite Normal:
## AF 50mm f/1.4 and AF 50mm f/1.7

If the lens programme is expanded even further one can be sure that more focal lengths will be utilized twice. In the initial range only the standard focal length is represented twice. There is about half an aperture stop between the two lenses and a price difference of about £50.

The advantages of the faster lens are obvious. The picture in the viewfinder of your Minolta 7000 seems even brighter and more brilliant, the narrower depth of field at full aperture makes it easier to work with selective sharpness. On the few occasions when you focus manually both factors have a favourable effect.

The advantages of the slower standard lens are that it is cheaper and 45g lighter, a weight advantage which is of interest only if you are a mountaineer and have to be careful about every gram.

Which one should be recommended? If your purse dosen't mind, the f/1.4. If you would rather invest the difference in films, or save it for another lens, then the f/1.7 is a good choice because its performance is every bit as good.

What does one need a standard lens for? If you listen to

Considered by some to be boring, but valuable on many occasions, the standard lenses AF 50mm f/1.4 and AF 50mm f/1.7

committed amateur photographers you may be told the 50mm is boring and just about good enough as a stand-by with its faster speed to supplement the slower zoom lens.

The standard lens is a jack-of-all-trades. You can photograph landscapes during your holiday, as well as architecture. Although you cannot take any close-ups, you can still get close enough to produce enlargements of portions of a picture (without, as with the wide angle, too much distracting background). You can pre-select a snap-shot setting with a small aperture so that you are always prepared for unexpected situations (at the right distance range), and you can take convincing half-length portraits, even if proper head and shoulder portraits are not possible. All this with a perspective which we regard as normal and therefore pleasant.

The 50mm is not at all superfluous, only people with other preferences regard it as a "universal amateur" and of no use.

## Not Quite Short — But Not Long Either: AF 85mm f/1.4 AF 100mm f/2 AF 135mm f/2.8

Medium telephoto lenses are popular for a wide variety of

purposes, from portraits to sports photography. They allow you to photograph people from a distance, reducing self-consciousness in your subject and giving the picture a more natural perspective. The 85mm or 100mm in particular give an ideal perspective for portraits. For sports they let you get closer to the action without getting in the way. The AF 85mm f/1.4 is an ideal counterpart to the AF 35mm f/1.4 for candid pictures in available light. Although not a snap-shot lens, because at its large aperture focusing has to be very accurate, it is valuable for available-light photography.

The 135mm has had to give up its role as universal telephoto lens to the 200mm. So the 135mm has been reduced for some time to the unthankful role between the portrait lens with 85mm or 100mm focal length and the real telephoto lens of 200mm. Just as the 28mm does not show the obvious, steep perspective of the 24mm, so the 135mm does not have a tendency to the flat, bunched perspectives of the longer telephotos.

You can certainly use the 135mm for portraits, with the advantage that you do not have to crowd your victim too much and are still able to photograph the head and fill the format. At full aperture and with a background at the right distance the narrow depth of field still shows the desired separation of the head from the distracting background (make sure, before the shot, that the aperture does not turn out to be much smaller, remember the antlered grandfather; branches growing out of the head, or a lamp-post protruding from the hair-do, are not considered flattering).

The 85mm and 100mm lenses can be used equally well for isolating the subject from the background. Although they have shorter focal lengths than the 135mm, one can compensate for this by taking advantage of their larger maximum apertures.

With the 135mm on your Minolta 7000 you can already compress distance and render subjects large in the picture although they are quite a distance away. It is tempting, naturally, to attach the 135mm and remain where you are if there is something worth photographing at a certain

AF 85mm f/1.4, AF 100mm f/2 AF 135mm f/2.8.
Considerations of cost, weight, and lens speed will determine choice here. They are all suitable for portraits and the 135mm is usefully long enough to bridge distances and pick out details.

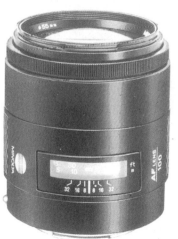

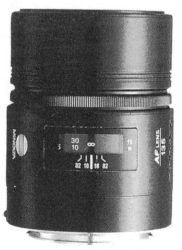

distance. But do remember that the position where you stand determines the perspective and the same subject might have a better effect from a short distance with a short lens! Walking towards a subject, encircling it for the best view, is still the best way to achieve good pictures.

With a one metre minimum focusing distance with this lens you are not getting into the range of macro-shots, but you can easily extract details from a subject to complete the overall view for the photo album or slide show as an effective means for reducing boredom in your viewers.

## The Universal Telephoto: AF 200mm f/2.8 Apo

Why the universal telephoto? Because the focal length of about 200mm is really the longest that is convenient for the ordinary amateur to use. It is still a reasonable size and weight; on most occasions in normal lighting it can be used hand-held. Furthermore, you are likely to use it more frequently in general photography than the longer focal lengths, unless you are particularly interested in sports or wild-life photography. With its 4X magnification over the standard 50mm lens, you can emphasise the subject whilst cropping-out unwanted background detail and distractions. You can use its restricted depth of field, particularly at full aperture, for rendering the background as an out-of-focus blur, which can indeed make an attractive pattern of colours.

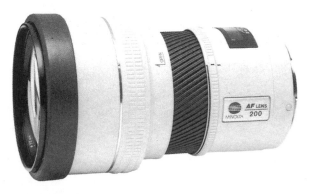

The most useful all-round telephoto is the AF 200mm f/2.8 Apo, particularly if you want higher speed and prefer not to use a zoom.

# A Lot of Lens for a Lot of Money:
# AF 300mm f/2.8 Apo
# AF 600mm f/4 Apo

With the 300mm f/2.8 Apo costing as much and weighing as much as your Minolta with a substantial outfit of lenses, and the 600mm being proportionately bigger in both senses, these two lenses are really in the professional sphere. They are magnificent for sports or wild-life photography. They offer tremendous optical "reach" for human interest photographs, and there is no substitute for this kind of lens when photographing unapproachable subjects such as those in dangerous situations. They are used in architectural photography because many buildings can best be appreciated from a distance.

With these long focal lengths you can really enjoy the excellent auto-focusing system of the Minolta, especially for sports and animal photography when speed of action is important.

Because of the high lens speeds there is no problem with these telephoto lenses in getting your shot, even under bad lighting conditions. Also because the Minolta AF-system is hard at it, fast and safe telephoto pictures are not difficult, even if the light is not ideal. The very large maximum aperture of the 300mm also makes "hard-work" easy for the shot without a tripod, but considering the long focal length, you should always use the faster films. Regarding shutter speed: $^1/_{500}$sec. is all right, but whenever possible $^1/_{2000}$sec. is better.

Although these lenses are ideal for fast moving subjects, a 300mm also feels at home in other areas of photography. You can take beautiful landscape photos, and in this case the so-called aerial perspective shows up well: the impression of distance is not created by perspective lines but by ''blueing'', which means that the parts of the subject which lie in the distance dissolve in the blue haze of the atmosphere. In addition, the increasing blurring of the background

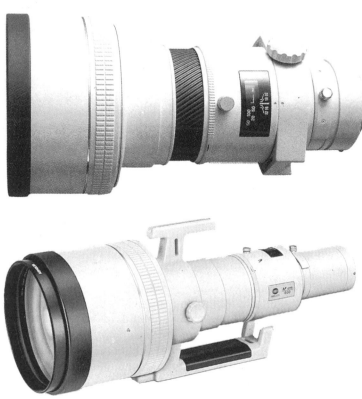

Two specialists, especially for sports and animal shots; the AF 300mm f/2.8 Apo and 600mm f/4 Apo.

intensifies the impression of depth. This is in contrast to the needle-sharp background of wide angle shots with their large depth of field which sometimes counteract the impression of depth created by the perspective.

The effect of haze, depicted positively here as a means of expression, can spoil the effect of many photos taken with the long telephoto if a large distance has to be bridged. Then the haze in the air, the floating dust particles, and the flickering caused by rising warm air destroy the sharpness which would otherwise be obtained with this lens. Don't

blame Minolta though if your telephoto picture is not completely sharp – just stop and think if the lack of sharpness might have been in the air!

You may be wondering why these lenses are ivory instead of black. It is because in the sun a black finish absorbs heat more than a white one and with lenses of this size expansion could affect the precise adjustment of the optical components inside.

## Tele Converters:
## AF 1.4X
## AF 2X

If you cannot afford a long telephoto lens, or would only have occasional use for one, then the best investment would be one of these tele converters. The AF 1.4X multiplies the focal length 1.4-times. Thus the AF 200mm f/2.8 Apo becomes equivalent to a 280mm lens. With the AF 2X it would be equivalent to a 400mm lens. Because the converters are apochromatically corrected an Apo lens retains its apo quality with the converter. The two tele converters are for use with Minolta AF telephoto lenses of 200mm focal length or more. The converter is mounted between the AF lens and the camera body. The built-in ROM IC (Read Only Memory

Tele Converters AF 1.4X Apo and AF 2X Apo give you a wider choice of longer focal lengths at a very modest cost.

Integrated Circuit) will transfer all information, including effective maximum aperture, from the lens to the camera.

There is, however, one penalty you pay for this apparent gift of increased focal length. That is a reduction in lens speed. This is because the physical diameter of the maximum aperture of the lens has not been increased with the increase in focal length. With the 1.4X converter the speed will be reduced by half and with the 2X converter by a quarter of its normal value. Thus the AF 200mm f/2.8 Apo with the AF 1.4X converter will become equivalent to an AF 280mm f/4 Apo lens and with the 2X converter it would become equivalent to an AF 400mm f/5.6 Apo lens.

## Specialists in Close-up:
## AF-Macro 50mm f/2.8
## AF-Macro 100mm f/2.8

Although macro-photography enjoys great popularity, it is difficult to define what is meant by this term. There is no proper definition as to what macro-photography means. The Deutsche Industrie Norm (DIN) only distinguishes long distance shots with a reproduction ratio up to 1:10, close-ups with a ratio of 1:10 to 10:1, and photo-microscopy with a reproduction ratio from 10:1.

For most photographers macro-photography is what, according to DIN, should be called ''close-up photography''. You are therefore talking about macro-photography if the magnifying scale lies between a minification up to ten times and a magnification up to ten times. I shall keep to this. But you are only able to cover half of the macro-range with the AF Macro 50mm f/2.8 and AF-Macro 100mm f/2.8, the one from a ten times minification up to life-size. However, all this as mentioned before can be accomplished without intermediate rings and with the advantage of automatic focusing.

If you photograph flowers, your coin or stamp collection, or if the structures and colours of semi-precious stones

*Above: A perfectly normal landscape shot with a super wide angle, where the great depth of field makes the picture. The fireworks lend it its special attraction. Photo: Ralf Strohmeyer*

*Below: Symmetry as a means of creation. Nothing detracts from this well composed picture; even the chosen colours support the impression of a calm scene. The traffic signs, which add a little colour, form a counterpoint. Photo: Klaus Hoffman*

*Above: The tree does not just liven up the foreground, but it also brings a breeze of friendliness to the whole picture which would otherwise seem rather desolate. Photo: Lothar Beck*
*Below: The avenue, lined by cypress trees, leads the view into the distant landscape. A shot which shows that even telephoto lenses can be used superbly in landscape photography. Photo: Peter Diersch*

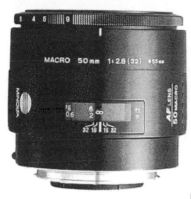

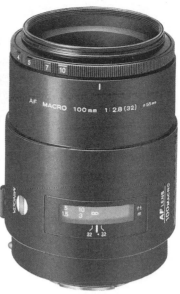

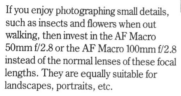

If you enjoy photographing small details, such as insects and flowers when out walking, then invest in the AF Macro 50mm f/2.8 or the AF Macro 100mm f/2.8 instead of the normal lenses of these focal lengths. They are equally suitable for landscapes, portraits, etc.

fascinate you, then the automatic focus is exceedingly useful. It is also a pleasant convenience which makes the tiresome backwards and forwards focusing a thing of the past. The is not to be dismissed, because the very narrow depth of field makes successful close-ups dependent upon very precise distance setting. This precision, however, is made more difficult because the view-finder image becomes quite dark because of the long extension and the intermediate ring.

One particularly notices how much the auto-focus would have helped in the past in the macro-range if one enjoys photographing small animals, which don't usually wait around until one has finally focused. It is no longer a problem with the automatic focus to get a quick shot, as long as one does not exceed the alignment distance.

When photographing small animals or insects the 100mm lens is the better choice because it enables you to be further away with less chance of frightening your subject. The 100mm,

with twice the reach of the 50mm, can also be of benefit in reaching wild flowers, etc., in difficult positions, without trampling down any others around them.

Macro-lenses are not simply specialist lenses for the reproduction of small originals. They are normal lenses of a certain focal length, designed to give their optimum performance in the close-up range, where most lenses are weakest.

The AF Macro 50mm f/2.8 is most definitely an alternative to the standard lens. Although it is two aperture stops slower than the 50mm f/1.4, it offers continuous focusing all reproduction ratios up to 1:1, a very much larger application range. So if you are seriously interested in close-up shots, and not so much concerned to get a shot in smoky bars without flash, you should decide on the macro-lens (if you think your budget can take this additional financial burden).

Macro-photography is a vast subject in itself and it would lead us too far if I were to discuss it in detail. An important point is that if you want to take macro-pictures at a reproduction ratio of less than 1:10, you should invest in a tripod which can be put close to the ground and gives the camera plus macro-lens enough support at a low level. Just as with telphoto lenses, macro-lenses also magnify the slightest shake with unpleasant results.

Because the reproduction ratio changes automatically with the distance setting, you will soon be aware of a problem during macro-shots: you have assembled your tripod, fixed your camera to it, and focused on your subject. A critical look into the view finder, however, shows that the view is not quite right. You then have to move the tripod a little forward or backward and re-focus, which completely spoils your fun after the eighth time. Even if you want to take a picture at a certain reproduction ratio, you are confronted with a similar difficulty. The ratio can only be obtained with a certain distance from the object and if you have to adjust by moving the tripod backwards or forwards you will be surprised how tedious it is.

But you can keep your adrenalin production to a minmum. Buy a lens slide carrier, which is fixed to the tripod and carries the camera with the macro-lens. Now you can quite comfortably arrange the camera for a portion of the subject and at the correct distance which is suitable for the reproduction ratio you want because you can continuously move the camera-plus-lens forwards and backwards. A gear mechanism makes this possible. Such a lens slide carrier is divided into two setting ranges, one for coarse and the other for fine adjustment, and can be moved as a whole, forwards and backwards on the tripod.

If as a mineralogist you want to photograph your stone collection, or as a philatelist your stamps, or if you need to reproduce pictures from old catalogues or books, then you

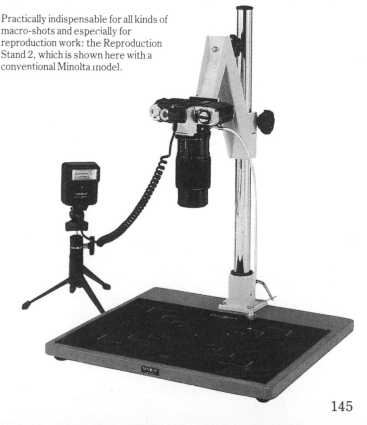

Practically indispensable for all kinds of macro-shots and especially for reproduction work: the Reproduction Stand 2, which is shown here with a conventional Minolta model.

need the Minolta Reproduction Stand II for this purpose. It is a tripod and lens slide carrier all in one. It is not, however, any use for shots in the wild!

Also of value for close-ups is the Angle Finder, which allows you to look at the view-finder image when the camera is close to the ground, or from the front when it is on the reproduction stand. It is thus a small, but useful accessory. A remote control cable should not be absent from your macro equipment either, the shorter type RC-1000S is good enough. Although the release on the camera is operated very lightly, it can still happen that after many exposures the camera is put out of position bit by bit, and the field of view, which was supposed to remain the same, slowly changes from that which was intended.

## Fixed Focal Length Versus Zoom

After we have become acquainted with the AF Macro lenses, the final representatives of the fixed focal length lenses, and before I introduce you to the zoom lenses from the initial range of lenses for the Minolta 7000, a few words about the two types of lens.

Zoom lenses have enjoyed a bad reputation for many years. The sharpness, it was said, was poor, and also the brilliance of the pictures could not excite anyone to jump up and down.

That was correct at one time, and has remained as a prejudice against zoom lenses, but it is recognised by unbiased photographers to be wrong now. Naturally zoom lenses have profited from the developments in lens technology. New computer programmes have worked out new zoom lens designs and new ways of manufacture have converted these plans into good and excellent lenses. The difference between good and excellent, which could be gauged by lavish technical tests, got smaller and smaller and it is now of no importance for day-to-day photography.

This does not mean that every newly manufactured zoom

has to be classified as good or excellent. There is always an acceptable standard whereby lenses are sufficiently good to produce album pictures up to a size of 9x12cm or 13x18cm. There are also brand new designs, which still have to prove their worth, but which should have reached a good standard of quality within a few years.

Most certainly Minolta zoom lenses belonged in the past, and belong now, to the upper class of lenses with variable focal length. Also extreme focal length ranges like 28-135mm are already well under control by the engineers. So as far as picture quality is concerned one has no need to worry about the zooms.

Why are there still fixed focal length lenses at all? The picture quality is still a tiny bit better (for sharpness fanatics), because of their simpler construction. Apart from that, every single fixed focal length is faster than the equivalent zoom lenses by one aperture stop on average. This (together with their low susceptibility to reflections) is a strong argument for available-light specialists (that means in simple words that the photographer does without flash or photographic lamps).

The disadvantage of the fixed focal length is more noticeable for the slide enthusiast than for the black-and-white or colour print photographer: that is the disadvantage of the fixed field of view. People who produce slides have no chance to cut off the annoying borders, or to simply leave them out if they enlarge their own prints; the slide determines the format. If you want to push an irritating intrusion out of your picture, you can only change position with the fixed focal length, and with that you also change the perspective. Perhaps a change of position is not possible either because the necessary step forward is prevented by a clear, but cold mountain stream. If a step backwards isn't possible either, because you are already standing against the wall, then all you can do with fixed focal lengths is to reach for your wide angle lens. This will have a much larger field of view than the lens with which you were just unable to capture

the building, and will give you a completely different picture to the one you really intended to take.

That can be solved much more elegantly by the zoom lens, if this does not take you too close to the focal length limits. Within the focal length range, however, you can alter the focal length millimetre by millimetre and narrow or widen the field of view by single degrees. Also you can place your subject in the picture as exactly as the format ratio of 2:3 of the slide allows without changing your position.

That is the great advantage of zoom lenses as opposed to fixed focal length ones. Only secondary is the fact that a zoom lens can substitute for several fixed focal length lenses and is therefore very congenial for the comfort of the photographer. Instead of a big bag full of lenses, a small one is sufficient, containing just a camera body, two lenses and a flash gun, and you are ready for all eventualities.

Naturally the zoom, much more than the telephoto, tempts one to take all pictures from a single position and to zoom into the details from the overall view. The advantage of this is that the overall view and the selected details show the same perspective. The disadvantage is that no new picture ideas can develop, which often turn up when you stalk the subject. The question of whether to acquire a zoom rather than fixed focal lengths is no longer a decision between good and bad lenses, but a decision between lens speed and a continuous, variable frame, or between highest demands on picture quality and convenience. People who photograph with zoom lenses have the greater creative freedom, coupled with sharpness and brilliance, which was never dreamed of at the beginning with the introduction of the ''rubber lenses''.

The question need not inevitably be between zoom or fixed focal length. Much more often one has to decide which lenses make up an ideal outfit for varied demands. Zoom and fixed focal lengths are not in competition with one another, they are partners which complement one another to your advantage.

# The Zoom Focal Lengths

With a setting range overall from 24mm to 300mm, the Minolta AF-zooms offer all focal lengths from the genuine wide angle to the genuine telephoto. All AF-zooms are rotating zooms, for which you set the required focal length by a ring. Set into the ring is the reversing switch for macro-shots, which can be taken up to the largest reproduction ratio of 1:4. However, you must do without your auto-focus convenience if you depart from the standard setting range (exceptions are the 70-210mm) and 75-300mm zooms).

You achieve sharp pictures with your zoom in its macro-range by two methods. For both you have to set the auto-focus/manual switch next to the camera bayonet to ''M'' and turn the distance ring to the shortest distance, if you want to achieve the greatest reproduction ratios. (The sharpness indicator in the view finder will have already been switched to manual focusing by the release of the macro key). You can then either set the focus from a certain distance by turning the focal length ring, or pre-select a reproduction ratio by turning the focal length ring and then bringing the camera into the correct position. The strength of the zooms does not lie in the macro-range of course, which is not sufficient for the macro-photographer and is just regarded as a little extra benefit for the photographer who is only occasionally moved to photograph in close-up a butterfly, a bloom, or the delicate net of a spider's web on which dewdrops are sparkling.

The advantages of the 28mm are known: it is of great use for snap shots, can help anywhere the restriction of space hinders working from more usual distances, is not too extreme for architecture, and is a pleasant focal length for landscape photography because the perspective is not yet too pronounced.

The 35mm is really more of a standard lens with a wide angle, rather than a real wide angle lens. That comes from the fact that we do not look ahead rigidly and the field of view of about 45°, which the standard lens was based upon, is

really only valid for the view which we can see sharply at any one time. Because our eyes are wandering, we take in a larger part of our surroundings quite knowingly, and in focus, and we don't realise that this impression is put together by sensing one picture after another. Many photographers, when they look through their 50mm standard lens for the first time, are surprised that they see less than with their unaided eye. This does not happen too markedly with a 35mm.

The 35mm, just as the 50mm, may be used as a genuine all-round lens, being useful for almost any type of subject. (That some things don't work, that for example a duel between two footballers at the kick-off point cannot be photographed with the 35mm focal length is no argument against it. You can, however, capture some fascinating penalty area scenes from the goal line or through the net).

What you can capture with the 50mm was mentioned during the introduction to the two standard lenses. It can be used for all purposes, although it is of interest to the specialist only as an additional facility to go with the necessary longer or shorter focal lengths.

The focal lengths between 70 and 85mm are also universally useful, and are especially recommended for portraits. The longer focal length makes possible format-filling shots of the head from a longer distance, which assists in making the person being photographed more relaxed. It also makes sure of a pleasant perspective, which is neither too steep (wide angle lenses produce caricatures with big noses and small ears) nor too flat (the face looks peculiarly flat when photographed with a telephoto lens).

Apart from that, the short telephotos can be used for photographs over a larger distance once in a while. They can isolate subjects out of the landscape, and the spatial depth is already slightly compressed.

The focal length of 105mm also belongs in this range, a long portrait telephoto, which is very suitable for lots of subjects. In architectural photography details of facades can be photographed from a larger distance, avoiding the close view

from below. Children can be watched from the background with the 105mm and they soon forget about being photographed. Also with a 105mm focal length details can be picked out from a subject which is also photographed as a whole with the 28mm.

The 135mm shares nearly all the advantages of the 105mm, but it is less suitable for portraits. It is better for shots over a larger distance and its narrower angle of view is useful when the subject needs to be closely framed.

At 200mm focal length things finally start to get serious with the telephoto. Now things can be taken from the far distance and fill out the frame; now details can be captured from a medium distance. Without any doubt the 200mm is the universal telephoto lens. It is not long enough to require a tripod for most shots, the depth of field is relatively small but doesn't give one a headache, and although the field of view of 12° flattens the perspective considerably, the individual features in the subject are bunched up without crowding each other too badly.

All these focal lengths are represented in the Minolta zooms, but the range also extends down to the ultra wide-angle 24mm and up to the very useful 300mm telephoto.

## The Three Universals:
## AF 28-85mm f/3.5-4.5
## AF 28-135mm f/4-4.5
## AF 35-105mm f/3.5-4.5

If every now and then only one lens accompanies you on a photographic trip, but you still want to be forearmed for all subjects, you can choose one of the three Minolta AF zoom lenses.

Two of these lenses are in direct competition: the 28-85mm is recommended for its larger wide angle range whereas the 35-105mm has more "telephoto" to offer. Which one of them you decide upon depends rather on

whether you are a wide angle type or whether narrower views appeal to you.

If your tendency is towards the wide angle, I recommend the 28-85mm, which you would naturally complement with the 24mm. But if you would rather bring some distant detail into closer view, or if you wish to show a detailed section from a larger subject, then you should decide on the 35-105mm. For this lens the 200mm would be the ideal partner to complete the range.

By the way, both lenses weigh exactly the same, so you can choose freely if weight is a criterion in your decision, and both offer the same macro-settings to a largest reproduction ratio of 1:4, which means that one cannot score more points than the other.

The third universal zoom of this club is larger and heavier. It does, however, reach from 28mm wide angle to short telephoto at 135mm and because of this can be rightly called the "lens for all eventualities". It does not let you down in conditions of restricted space, it brings the far distance closer, it is equally suitable for landscapes, architecture and portraits, as well as for nature and snap- shots, and you only have to complement it by a fast standard lens in order to make you totally and utterly happy – whether you are keen on "available light" or become enthusiastic about very close-up pictures.

The AF 28-85mm f/3.5-4.5, a universal zoom with emphasis on the wide angle range; the longest focal length is optimal for portrait shots, but not a genuine telephoto.

The 28-135mm f/4-4.5, a zoom, a single lens to cover a wide range of subjects.

Each one of the three lenses is a good "one-lens-outfit" if the Minolta 7000 and its auto-focus system enthrall you but you want to fall back on the extensive lens outfit of your "old" single lens reflex when taking shots on which you can spend a lot of time.

The 35-105mm f/3.5-4.5, like the 28-85mm this is a universal zoom, in this case with telephoto emphasis. However, it cannot cover the wide angle range.

## A Perfectly Normal Zoom: AF 35-70mm f/4

When the first 35-70mm lenses arrived on the market many

people predicted a quick decline of the standard lens. Indeed, many photographers decided upon such a zoom which, being little larger than the standard lens, nearly reached the limit of the wide angle range and also with its 70mm covered a little bit of the telephoto aspect. Nowadays even these lenses are coming under attack: the 28-85mm lens (and similar ones) dispute their position as substitutes for the standard lens.

If you have you eyes on a 35-70mm, you should deliberate on whether you like a versatile ''standard'' lens, in which case the 35-70mm is for you, or whether you would not really prefer a universal lens, in which case you should rather purchase a different zoom. The 35-70mm lens is to be recommended in another situation: if you have got the 70-210mm zoom and want to fill the ''wide angle gap'' without the focal lengths overlapping. In this example the equipment could be complemented at a later date by a 24mm.

The 35-70mm is an optimum ''standard lens'', especially as it is compact and easy to handle.

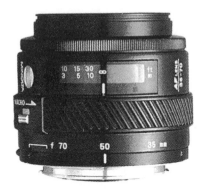

## The Wide-Angle Zoom: AF 24-50mm f/4

Lens technology has now developed to such an extent that high-quality zoom lenses can now be made extending right down to the ultra wide-angle range. If your interests are primarily in wide-angle photography then this is the lens for you. It offers you great creative versatility for photographing

expansive landscapes and it will let you precisely frame your shots in street scenes or with architectural subjects taken from close quarters.

There is no other zoom in the range that neatly complements this lens by taking over where it leaves off at 50mm. It really depends what your other interests are as to whether you choose a companion starting at 35mm or are willing to tolerate a gap and buy one starting at 70mm.

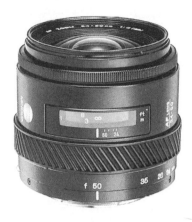

AF 24-50mm f/4, the zoom for the wide-angle range.

## The Telephoto Zooms:
## AF 70-210mm f/4
## AF 100-200mm f/4.5
## AF 75-300mm f/4.5-f/5.6
## AF 80-200mm f/2.8 Apo

That the zoom was able to get rid of its bad name may be attributed to a large extent to those lenses which had a treble zoom range of 70-210mm and which first achieved the standard of fixed focal length lenses. One of these classical telephoto zooms was among the first Minolta AF lenses, although it seems rather large and bulky compared with the

other auto-focus lenses. The reason for this is partly that this zoom, the only one of the new series, does not require a macro-reversing switch but maintains full automatic focusing. It can be focused down to 1.1m, which corresponds to a reproduction ratio (according to Minolta specifications) of 1:3.9. That means that a subject of 1cm length is reproduced 2.56mm long.

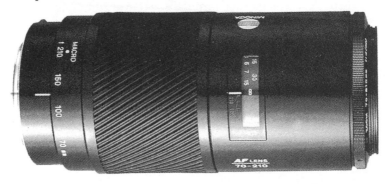

The AF 70-210mm f/4 together with the 35-70mm f/4 forms an ideal pair of lenses.

As with all 70-210mm zooms, this lens is superb as an all-round telephoto which incorporates also the portrait focal length. It can be used for sports and animal pictures, it has the effect of compressing distance in landscape pictures, and it makes it possible to take snap-shots without being noticed.

The AF 35-70mm f/4 and the AF 70-210mm f/4 make up a beautiful pair of lenses. They are a match for the majority of subjects, and only weigh down your photography bag by just under a kilogram, about two pounds. The 35-70 can remain on the camera all the time, as standard lens, and if you bear in mind that the Minolta flash gun, Program 2800 AF, allows you to focus automatically in the dark, then the lens speed of f/4 (which does not alter for the whole setting range of both lenses) should be sufficient.

If 35mm as a wide angle focal length is not short enough for you, you can of course buy the 28-85mm lens instead as the

partner to the long zoom. This also has the advantage that 28-85mm is of more use to you on its own than the 35-70mm so that the 70-210mm lens and the universal bag can stay at home more often.

The combinations giving 28 or 35mm to 210mm can be supplemented quite nicely with the macro-lens, and the 24mm also fits in well to make a very versatile outfit.

If minimum weight is important to you and you are not concerned about the more restricted range, then the AF 100-200mm f/4.5 would be a good choice. It tips the scales at just slightly over half the weight of the AF 70-210mm. It is also slightly slower in speed and lacks the macro range.

For the extended telephoto range up to 300mm, then the AF 75-300mm f/4.5-5.6 would be the perfect choice. A truly versatile lens and suitable for a variety of uses from sports photography to portraiture, as well as nature and wild-life. One can take a general scene of a sports event using the 75mm setting and then zoom right in with the 300mm setting to pick out an individual competitor or member of a team. The 4:1 zoom ratio gives you a magnification of 4X over its whole range and it also has a macro range extending to a 1:3.9 reproduction ratio.

Finally, if you are a connoisseur of image quality the AF 80-200 f/2.8 Apo is the lens for you, although at a considerable price. Like the 200mm, 300mm, and 600mm telephoto lenses, it has apochromatic correction. This means that the form of aberration known as secondary spectrum, which can

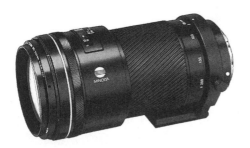

AF 80-200 f/2.8 Apo for the finest image quality.

degrade pictures taken with a telephoto lens in critical situations, has been reduced to a minimum.

# The Reflex Mirror: How the Picture Gets into the Viewfinder

No matter which lens you decide on, or which focal length you choose for a zoom, you always see in the viewfinder of your Minolta 7000 exactly what will be on the film later on, and thus what will be seen on the slide, although not necessarily on the print. But one thing at a time! How is it possible that the narrow frame of the telephoto can appear in the viewfinder just as well as the huge field of view of the 24mm lens?

One part of the solution lies in the mirror, the other in the pentaprism. The mirror is suspended in its resting position at an angle of 45° between the lens and the shutter and directs the light coming from the lens through 90° upwards. If you play snooker or pool now and then, or if you recall your school days you will remember the formula: angle of incidence equals angle of reflection, according to which the deviation of the light works within the camera. From the mirror the light reaches the focusing screen, which closes the mirror box at the top, and there the picture can be seen directly in many

The image appears the correct way round and the right way up in the viewfinder of the Minolta 7000, which is made possible by the hinged mirror and the finder prism. The viewfinder serves as central control for sharpness information and also gives information about special functions, such as exposure correction.

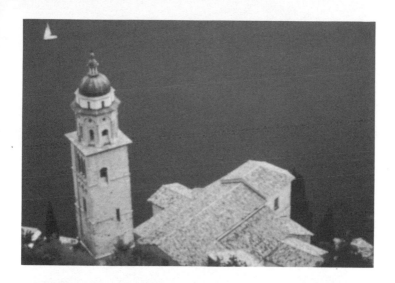

*Above: The church is set off against the calm background of the sea by the high position of the camera. Photo: Dr. Joachim Hildebrandt*
*Below: The small brown area of the house counter-balances the large area of dull blue. Photo: Armin Hohler*

*Above: The telephone wires lead the eye into the background of the picture; the asymmetrical composition of the picture (the hut shifts the main emphasis to the right) adds excitement to an otherwise very calm photo.*
*Photo: Ernst Müller*
*Below: The orange light immerses this scene in an unrealistic atmosphere; the bridge towers, which emerge from the fog, reinforce this impression.*
*Photo: Udo Kröner*

medium sized cameras, and some 35mm ones. Whereas it reaches the mirror (and the film) up-side-down and inverted left to right, it is upright on the screen, but left and right are still inverted. If you have ever attempted to interpret a view on a focusing screen you will know how difficult it is (for the inexperienced photographer anyway) to decide quickly on which way to move if one wants to alter the framing of one's picture.

In our camera the picture is turned around again in the viewfinder prism and then the bearings are correct for all directions: top is top and left is left. Because the mirror passes exactly the same picture to the focusing screen which the lens is projecting onto the film, you always see in your viewfinder what will be seen on the film later on.

That nothing different is captured on the slide is understood, the slide is nothing else than a piece of film which was reversely developed. Similarly with the negative, which is a piece of developed film, still showing the subject exactly as you have judged it in the viewfinder and passed as acceptable. However, when you receive your prints after enlarging, there is something missing from the picture at some place, usually from where it was important. Why is that? Ever since Oskar Barnack had the idea to change the direction in which the film was running and to make one still picture out of two little cinema-sized pictures, the 35mm picture with its side ratio of 2:3 has been quite a problem child. Photographic papers have been cut for different dimension ratios, and whoever wants to enlarge a 35mm negative completely has to leave a border on the paper. On the other hand if all the paper is to be covered with picture, then a strip of the negative has to be left out, and that is exactly what happens in the "picture factories" of the processing labs.

When you develop your own work you can choose the lesser of the two evils, unless you limit your format to 20x30cm. Two sheets of this size can be made in the dark room out of a sheet of 30x40cm, and recently this has become available as the only suitable 35mm-shaped format.

# POCKET SIZED SUN: FLASH GUNS

Perhaps you belong to the generation which still remembers the school photographer with his large-format bellows camera, his black cloth and his magnesium flash. The good man had put a heap of magnesium powder onto a metal pan, he then opened the shutter and ignited the powder which burnt with a bright flash and lit up the class room sufficiently for the exposure. Nowadays it is a lot easier to send flash light into the dark and take well lit pictures, even on the darkest night.

A faster flashing rate is obtained by use of the Control Grip 1000. As the infra-red flash of the flash unit itself would not be pointed directly at the subject, a separate infra-red flash unit is supplied with the Control Grip.

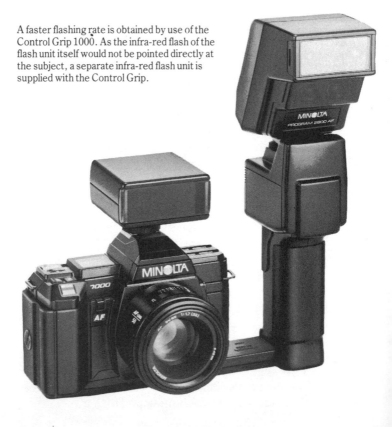

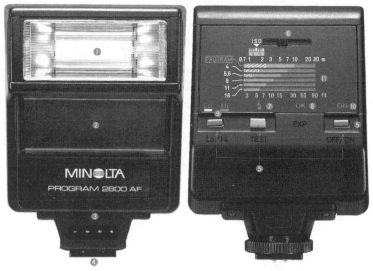

The smaller of the two special flash units, the Program Flash 2800 AF. The infrared measuring flash (2), situated under the normal reflector (1), projects a red pattern onto the subject, guaranteeing AF functioning in the dark. An external power source can be attached by a plug so that the flash rate time is shortened and the flash number increased. The contacts situated in the foot (4) make the connection to the camera. The flash unit is operated by three keys: main switch (5 – right), testing switch for pre-release of a flash (5 – middle) and selector switch (5 – left) for large range (Hi) or fast flash rate (Lo). The indicators show that the unit is switched on (10), which performance level was chosen (9), that it is ready to fire (7), and that the flash illumination was sufficient (7). The film speed slide (6) is only of importance for the range scale (11), the ASA value is taken up directly by the camera.

There are three specially developed flash guns for your Minolta 7000. The Program Flash 2800 AF may be regarded as the general purpose gun for amateurs. The Program Flash 1800 AF has a lower light output but it is very compact, lightweight, and pocketable. The Program Flash 4000 AF is the ultimate in flash guns, with much more power and many other facilities, for the serious amateur and professional photographer.

## Program Flash 2800 AF

I will describe the Program Flash 2800 AF more fully first, but bear in mind that features such as TTL metering and AF-assist illuminator apply equally well to the Program Flash 4000 AF and the Program Flash 1800 AF.

The Program Flash 2800 AF may be a small and lightweight piece of equipment (with respect to its double function), but with a guide number of 28 it is quite efficient. Its operation on the Minolta is totally without problems; you only have to push it into the accessory shoe and switch it on. Everything else happens automatically. The film speed, which is just as important for the calculation of the correct flash exposure as it is for normal exposure, is transmitted directly to the flashgun. The synchronisation time ($^1/_{100}$sec. or in dim light $^1/_{60}$sec.) is set automatically by the camera, as soom as it is ready to fire, and the flash exposure is measured "TTL", which means through the lens just as the normal exposure, and is suitable for the aperture which has also been set automatically.

## Guide Number

The guide number of the device is 28, from which it derives its name. The guide number is a quantity which indicates the performance of the flash gun, referred to a certain film speed and to a measurement of the distance (in either metres or feet). Some years ago, when ASA 50 films were the standard material, the guide number was referred to ASA 50, but today ASA 100 is the point of reference.

The aperture needed for correct flash exposure can be worked out by distance and guide number, according to this formula:

Aperture = Guide Number (m) / distance to subject (m)

With the "2800 AF" aperture f/4 has to be set at a distance of 7m if the exposure is to be correct. If you look at the back of

the flash gun you will see that a maximum range of 7m is given for aperture f/4 at ASA 100.

## Metering Through the Lens

The manual work of aperture setting is superfluous with the "2800 AF". Only if you work with a flash gun of older design do you need to remember the guide number formula.

The correct flash exposure with the "2800 AF" is calculated by the Minolta 7000 in a different way. The light reflected by the subject passes through the lens, under the raised mirror, then through the open shutter curtains onto the film. From the shiny surface of the film a small portion is reflected again and registered by a meter cell which is situated at the bottom of the mirror box.

This TTL flash measuring function will work in the automatic programme as well as in the aperture and shutter speed priority modes, and even in the manual mode.

As soon as the flash is ready and all the details are in the viewfinder and in the display, the camera sets $^1/_{100}$sec. or $^1/_{60}$sec. depending on light conditions, as well as a suitable aperture in the programme or aperture priority modes. The maximum range for the chosen aperture can only be read on the back of the flash gun for lenses with a maximum aperture of f/2.8. (For lenses with a smaller maximum aperture the maximum range is given in the operating instructions).

During aperture priority, even with flash shots, the decision as to which aperture is to be used is entirely yours. Therefore you can decide whether you strive for maximum range with a wide open aperture (at any rate: 20m at f/1.4 and 100 ASA), but in that case accept a narrow depth of field, or whether you illuminate a smaller field, which would remain sharp from front to back. In this work the film speed comes into its own: the faster the film the greater the range.

How far away the subject, which is to be illuminated by the "2800 AF", may be also depends on the operating mode you choose, "Hi" ( = high) or "Lo" ( = low). "Hi" means that

the flash power is used for a large range, but that it could take a little while before you can use the flash again. ''Lo'' means that the range is reduced in favour of rapid repeat flashes.

At aperture f/5.6 and with 100 ASA film, the subject in need of flash illumination can be 28/5.6 = 5m away from the camera if stop ''Hi'' was chosen, and only 7/5.6 = 1.25m away if stop ''Lo'' was set (and with that the lower code number 7). But now you can photograph the closer subject without any problems whatsoever with the auto-winder set a ''C'' taking two shots per second.

In order to be sure that everything is working satisfactorily you can fire a test flash by pressing the small key ''Test'' on the flashgun. If the flash exposure was correct during a shot, a green ''OK'' symbol will light up on the back of the flashgun. That the correct flash exposure was used is also shown in the viewfinder by a flashing of the ''flash ready'' symbol. This ''flash ready'' indicator in the viewfinder is extremely valuable: it means you don't always have to remove the camera from your eye in order to look for the ''flash ready'' indicator on the flash gun to see whether it is ready or not. You can leave your eye at the eyepiece and follow your subject, should it be moving, and still know whether you can be sure of enough light when releasing the shutter.

Another word about shots with the auto-winder, that means a frequency of two pictures per second with flash light: you have to switch off the AF unit because it would fire the red pre-flash before every flash and hence decrease the picture frequency.

Apart from that, the pre-flash is one of the most important aids of the Minolta 7000 system. Only with its help is it possible to make automatic focusing work even in the dark. Maybe not quite the same as during the day, but still very effective. The range of the pre-flash is limited to 5m, and the whole thing only works if a lens with a focal length of 50mm is used. It does work for slightly larger focal lengths, but you should test that first. If the pre-flash is not sufficient to give the distance setting, then this is shown clearly in the

viewfinder and you can still focus manually.

## Filling-in Made Easy

"Fill-in-flash" is a phrase which still causes some photographers uncertainty because it depends on the correct mixture of existing light and flash light, and that used to be a tricky matter. Not with the "2800 AF", which was presented with a special fill-in-flash programme by Minolta. If the ambient light referred to ASA 100 needs an EV of 13 or more for correct exposure, then the Minolta 7000 switches to the synchronisation time of $^1/_{100}$sec. which compared to the "normal" synchronisation time of $^1/_{60}$sec. means that about a third less ambient light will reach the film. The flash, which brightens the shadows, has less chance to over-expose the light parts of the subject. The fill-in-flash is, as you quite correctly assume, an alternative to the use of exposure correction factors in the plus-range, or to the use of the memory lock in the case of "dark subject in front of light background", i.e. the back-lit shot.

By pressing the key "Test", a flash can be fired without the camera exposing a frame.

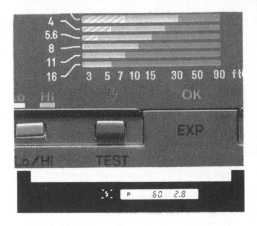

The flash synchronisation time is set automatically for the programme mode if the flash is ready: the aperture is also set automatically.

The handy combination of Minolta 7000 and flash unit does not have to be removed from the eye to see if the flash is ready to fire. This is shown in the viewfinder.

If the shutter release is touched very gently, the focusing works automatically and, if required, also registers the red pre-flash.

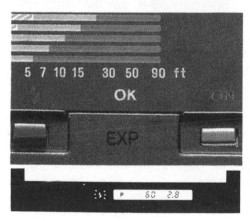

The "OK" indicator lights up again after the correct exposure, and this is indicated in the viewfinder.

## Slow Speed Plus Flash for Effect

The possibility of using slow shutter speeds with an automatically corrected flash has been known since the Minolta X-500. (Flash light for slow shutter speeds is technically no problem because the shutter is open long enough for correct synchronisation.)

You only have to get the "7000" to set a slower shutter speed than $^1/_{100}$sec. for such shots in aperture-priority mode, better still slower than $^1/_{60}$sec., and store this shutter speed. The flash gun is still switched off during this procedure.

When you switch it on the synchronisation time of $^1/_{100}$sec. is set. On pressing the AEL-key you get your "7000" to override this and set a shutter speed which is one stop faster than the one measured at first. If you now release, the ambient light is taken into account but the main subject is optimally illuminated by the flash. An example: you would like to photograph your partner in front of the splendour of the sparkling lights in a fair-ground alley at night, and you would like the lights to have the same effect as in reality, and that your partner stands amidst these lights. The camera may show $^1/_{30}$sec. at aperture f/5.6, but the shutter will actually stay open $^1/_{60}$sec. because of the action described above. The bright lights will be correctly exposed, the surrounding darkness will turn out a little deeper, and the person in the centre will be optimally illuminated by the flash.

For special effects you can set any shutter speed which is slower than $^1/_{100}$sec. with every aperture which you might favour; the exposure will turn out to be correct in every case. Whereas mischievous playing around with the aperture setting would at the most increase or decrease the depth of field, the alternative of varying the shutter speed gives rather more interesting results.

Let us imagine you choose $^1/_8$sec. and are photographing a subject which moves quickly. The flash will reproduce a phase of the movement needle sharp whilst at the same time the slow shutter speed makes sure that the movement is reproduced in a streaked manner. You can also achieve this effect by slow speed setting as described above, but it is quicker if you set the shutter speed and the aperture manually.

## Synchronisation Time

We have discussed the synchronisation time, and we have said that shutter speeds which are faster than $^1/_{100}$sec. are not suitable for flash. Why?

Think back to the explanation in the section on the focal

plane shutter! After release, the first curtain rushes past the film and gives way to the light, after the required time the second one follows and cuts the light off from the film. The film therefore is exposed in strips by the light which is available during the exposure time. The flash, however, only lights up very briefly and if one of the shutter curtains moves over the film surface during the illumination time the flash will throw its shadow onto the film. Because the flash gun fires practically without delay, the shadow of the first curtain is left for posterity. Because the picture can be seen in the finder with the correct side up and not inverted, but is still projected onto the film upside down and inverted, the shadow of the shutter curtain, which runs from bottom to top, will fall on the lower part of the slide or negative.

The synchronisation time is the time between when the first shutter curtain reaches its destination to when the second one starts on its journey. The film gate is completely open for a moment and there is no threat of shadow if the flash fires during that moment; this applies to any other slower speed as well.

## Wide Enough Illumination Angle

You can illuminate all pictures with the 2800 AF for which you use lenses with a focal length of at least 35mm, that means that you can take most pictures with the flash gun alone. It can happen at parties, or during the family photo in the best front room, that the 35mm is not sufficient to get everyone and everything into the picture, and then you have to reach for your 28mm. If you have purchased one of the zooms with 28mm starting focal length with your 7000 you will then want to use this zoom with the flash over the whole range of focal lengths. Well, provision has been made for all these cases with the 2800 AF with the wide angle diffuser screen by means of which the illumination angle can be adapted to the field of view of a 28mm lens. Because the light now has to brighten up a larger area, the illumination ranges

quite naturally decrease for the same aperture. In other words, the guide number alters, it becomes smaller so that when "Hi" is set it is reduced from 27 to 20, when "Lo" is set from 7 to 5.

## Corrected Flash

Just as during normal photography, the 18% base value, which is well known by now, can be used as an approximate value for flash photography.

The same requirements as for normal shots apply, that means that an under-exposure (minus correction) is needed for a small light subject in front of a dark background, and an over-exposure (plus correction) for a small dark subject in front of a light background; for a back lit situation you should not correct when taking flash shots but work with fill-in flash instead.

## Accessories for Flash

The accessory which is used most frequently with the "2800 AF" must be the Control-Grip 1000, which can be connected directly to the "7000" without a cable (!). It is equipped with its own batteries, and improves the flashing rate and number of flashes. The "2800 AF" can also be directly connected to the Control Grip without a cable and all functions will still be transferred as if the flash were installed in the accessory shoe of the camera. The fact that the flash unit sits to the side and above the camera when the Control Grip 1000 is in use does not present a big problem because the light which is reflected by the subject is measured anyway. Quite the opposite, it is advantageous for photographs of people because the lateral flash adds depth to the picture. When flash lights up directly from the camera it can give rise to "flat" pictures without detail.

Quite different is the question of the determination of focus by the pre-flash. The flash unit projects a small pattern onto the subject and has been set in such a way that the pattern

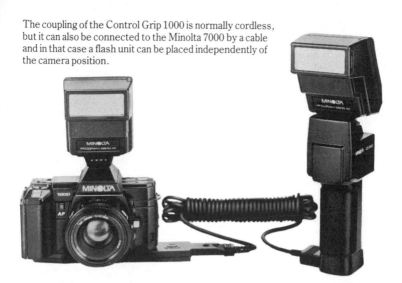

The coupling of the Control Grip 1000 is normally cordless, but it can also be connected to the Minolta 7000 by a cable and in that case a flash unit can be placed independently of the camera position.

lights up there where the lens can see it. This relationship does not apply to lateral flash. The "CG 1000", therefore, is supplied with an AF red flash unit, which is pushed into the accessory shoe, and allows for correct focusing in the dark.

A second way of using the control grip is also interesting for getting well-exposed flash pictures: the cordless combination of two flash units. One sits in the accessory shoe, the other one on the CG 1000. In this case the Grip controls the flash units in such a way that the main flash unit on the CG 1000 supplies two-thirds of the exposure, whilst the balance is supplied by the unit on the camera. This (in nearly all cases) ensures well filled-in flash photos. In order to utilize your fill-in flash more effectively, you can use the Control Grip 1000 by cable connection and remove it from the camera to a distance of up to 5 metres. The TTL flash control of your Minolta 7000 still keeps overall control.

It even makes sure of correctly exposed flash shots if two flash guns are not sufficient for you. You can use 3 flash guns at the same time with the triple-flash unit TC 1000 and be certain of well filled-in pictures. There are two problems with

173

this flash unit. Problem one: you have to work with cables which lead from the viewfinder shoe to the flash guns. Problem two: the flash only lights up for a fraction of a second so you can only establish very inadequately how light and shadow are distributed, even with test flashes. If you intend to work with several flash units more frequently (perhaps later on even with studio flash equipment and the relevant strong flashes), you should invest in a developing machine for Polaroid 35mm film. You can immediately check on the developed slides whether everything is all right.

The Minolta 7000 can even be released at greater distances without a cable, with the help of the Infra-red Release IR-IN.

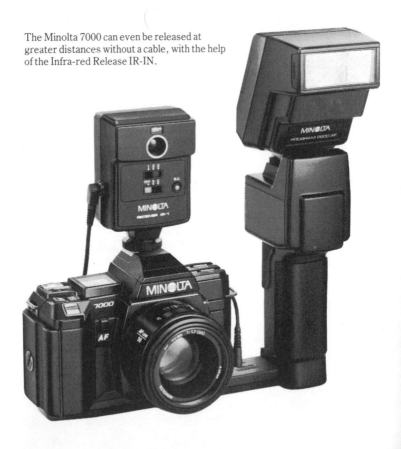

# Program Flash 4000 AF

The "4000 AF" is larger and has got a higher guide number (40, referred to metres and ASA 100), and not only can its reflector be swung and turned, but it is also adapted automatically to the appropriate focal length from 28–70mm (where the 70mm position is also used for all longer focal lengths). The back of the unit has an LCD display which informs you about all interesting flash data.

## Automatic Power Zoom

The Program 4000 AF has a power zoom head that automatically adjusts the angle of the flash to cover the angle of view of lenses between 28mm and 70mm. It has stops at 28mm, 35mm, 50mm, and 70mm. The zoom position is displayed on the back panel of the flash unit together with the flash ranges at these settings. For lenses of longer focal length than 70mm the 70mm angle is automatically set. The head can also be manually operated to give you total creative control.

## Choice of Power Output and Flash Range

There are 6 different output levels that can be selected on the Program Flash 4000 AF. These are indicated as MD, 1/16, 1/8, 1/4, 1/2, and FULL, in the top line of the LCD panel. The selected level is shown in brackets. Pressing the grey key on the right marked LEVEL will move the brackets to the next lower level i.e. from FULL to 1/2 to 1/4 etc.

In all shooting modes except MANUAL the lower line in the LCD panel displays "TTL" and the distance range, for example 0.7 to 8 metres (or feet if you prefer by operating a small switch on the top left of the panel). The displayed distance range depends on a combination of selected or automatically chosen values: film speed, power level, zoom effect position, diffuser

screen, on/off, and maybe also a preselected aperture value. The microprocessor within the Program Flash 4000 AF calculates from these parameters the resulting distance range and displays it. Thus you can always choose the appropriate power level for the subject distance so that the recycling time will be much quicker than it would be if you always used the flash at its maximum output.

## The Flash Which Comes Round the Corner

What can only be achieved with the ''2800 AF'' by means of the ''C G 1000'' and the connection cable, can be done without any accessories on the ''4000 AF'': you can arrange for the light to fall on the subject indirectly. Indirect flash has the advantage, as opposed to direct flash, that the light is softer and the shutter shadows, which are characteristic for shots with direct flash, are not such a serious problem.

Some time ago the expression ''bounce-flash'' was coined and it describes this technique very well. The light is thrown onto a reflective surface by the flash and then bounces onto the subject like a ping-pong ball. The most obvious reflector is the ceiling, which must be white for colour shots, or be capable of being printed white, because the light will be coloured by the coloured ceiling and give the picture a colour cast. It is obvious why this does not matter quite so much for a colour print film because the colour tint can be filtered out during enlarging.

The reflector, or the whole flash unit if it cannot be tilted, has to be pointed to the ceiling at such an angle, usually about 45°, that the light will be reflected back to the subject in a diffused and soft way. The bounce flash can also be directed to the subject via a wall, and for photography of objects, or table top pictures, it is strongly recommended that you have polystyrene sheets, mirrors of different sizes, or both at your disposal because they can be used to reflect the flash light into the shadow zones of the subject.

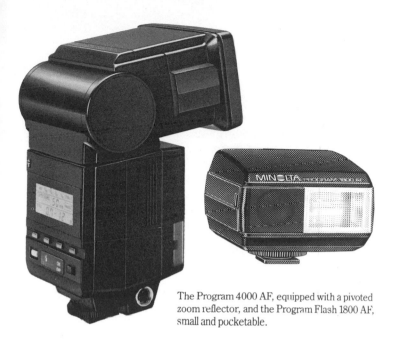

The Program 4000 AF, equipped with a pivoted zoom reflector, and the Program Flash 1800 AF, small and pocketable.

If you have the intention of employing indirect flash, perhaps even to use indirect flash for filling-in, but are unable to find a suitable ceiling or there isn't one available for outside shots, you can rely on Minolta's help if you use the "4000 AF". You swing the reflector upwards by 90° and fix the bounce reflector, which is supplied as an accessory and which fixes at an angle of 45° above the reflector and gives you a flash with a very soft light. During this procedure the TTL control always remains in control and correctly exposed pictures are no problem. You have to remember that the flash range remains the same, but the flash has to go a long way from the unit to the reflecting surface and then to the subject. For pictures with indirect flash pay special attention to the "OK" indication of the flash unit! When it lights up you can be sure that enough light has reached the film.

# Program Flash 1800 AF

The smallest flashgun in the AF series, this is very compact and lightweight and can be carried conveniently in the pocket. Its guide number is 18 (at ISO 100). Its illumination angle is equivalent to a 35mm lens, although with a wide-angle diffuser it may be used with a 28mm lens. It has only one output level and no distance range indication. Distance ranges for film speeds ISO 100 and ISO 400 are marked at the back for program mode. The range has to be calculated for other modes by dividing the guide number by the aperture value displayed in the viewfinder. The usual flash ready symbols appear on the flash gun and in the viewfinder. The answer-back signal for correct exposure is also provided in the viewfinder. It cannot be operated manually. If desired it will accept the quick recycling lithium 6v batteries instead of the normal four AAA batteries. Care must be taken however to select one that fits the battery compartment — not all makes do.

# Macro Flash 1200 AF Set

The Macro Flash has been specially designed to attach easily to most Minolta AF lenses to provide versatile illumination for medical and scientific use. It also appeals to the hobby photographer who likes to specialise in macro photography. The control unit fits in the hot shot of the camera whilst the flash unit fits onto the front of the lens. Four individually selectable flash tubes set at right angles to each other can be rotated about the lens. They can be fired simultaneously or in any combination to provide shadowing or modelling according to your taste. The TTL metering ensures that exposures will always be correct. The guide number is 12, but because it is used at such close range this amounts to a very high output. There are four built-in lamps to illuminate the subject for framing during autofocusing.

# A TRIO OF BACKS

The Minolta 7000 has been provided with no less than three data backs. There is one to suit everybody, from the family photographer to the scientist. These backs replace the normal camera back and offer facilities ranging from imprinting the date to controlling the camera.

## Program Back 70

People who take photographs of their growing offspring are often faced with the question: "Just when was it that the little one caused such a mess with the spinach? Was he or she already two or only........ or, no, that was shortly after sister's birthday, and she was........"

Surely there must be a very simple way to solve this problem and it is quite simple if you think about it: you go and develop your films immediately, frame the slide, or stick the prints in the album, and add the date in beautiful writing. But can you honestly say that you keep to those intentions for longer than three months? Soon the slides disappear in the drawer, unframed, and the pictures end up in an envelope inside a box, with the firm intention: "As soon as I have got a minute, I shall get all this into shape". Then if there is the time, the questions are asked........

There is another way to overcome such forgetfulness and that is called the Minolta Program Back 70. This is a camera back which can be exchanged very simply for the normal back. It has no film window, but an LCD-screen and seven keys. This Program Back 70 has got two functions: one is to assist your memory and get your picture collection into order; we shall talk about the other one later on.

On the display either the time, the date, the frame number, or a fixed code number can be indicated, and every one of these indications can be exposed onto the picture by you. You can decide which one of these data displays you are interested in by selection with the MODE-key, which also

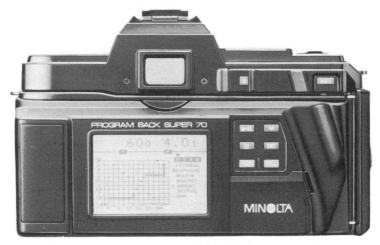

The Program Back Super 70 makes it possible (together with many other functions) to develop and store an exposure programme for one's own needs.

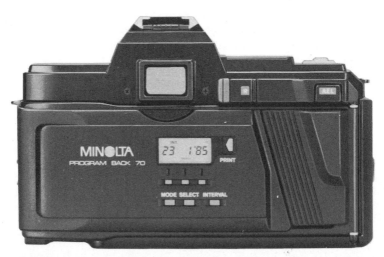

The Program Back 70 manages more than just exposing data onto the film. It is also capable of a certain amount of camera control.

shows "INT.S." as it is pressed down. We shall discuss this function at a later point.

You can select "date" and "frame number", by the SELECT-key. The date may be shown in the usual manner (i.e. day, month, year; or in the sequences year, month, day, or month, day, year, and you can set the frame counter in increasing or decreasing sequence.

In order to feed in the time, the date or any other number, you have to operate the three upper numerical keys, of which the left-hand one selects the first number pair, the middle one the middle pair and the right-hand one the last number pair. On depressing the number key, the relevant number advances by one digit; on depressing continuously the numbers run through sequentially.

By the way, you do not have to let the numbers run up to 99 every time for the time and date modes; the data back knows that each day has 24 hours and it also knows the number of days in each month (inclusive of leap years).

The printing-in of the date will be the one usually used by amateurs, because it shows when a certain event took place. Because the little orange-red numbers at the bottom of the picture are very informative on the one hand, but quite annoying on the other, it is advisable to record the date only on the first picture of a series. If slides are arranged in chronological order, it becomes obvious when the following ones were taken. As far as prints are concerned, the negatives always remain in their sleeves and therefore you can always reconstruct the correct sequence.

The indication of time, and time measured forwards or backwards from a certain point or a fixed time, is gaining more and more importance in technical and scientific work. It is also useful if you do photography as an adjunct to another hobby. Let us presume you want to provide photos of a certain series of microscope shots with a code number; this can be done with the selected code number. The first pair of numbers tells you, for instance, that it concerns the slide preparation of a mammal, the second one that it concerns a

muscle, and the third one at what magnification the pictures were taken.

If on the other hand you want to shoot a series of events and be sure that the sequence can be reconstructed without having to think too hard, even years later, then let the Program Back 70 count for you. It can count either forwards or, like a count-down, backwards, and you will always know whether a picture was produced before or after another one.

It could also be that on the one hand you want to show that this was the 13th experiment of a series, but on the other hand you would like to mark the picture sequence. Even that is possible: you substitute, in the frame number mode, the middle pair of numbers by two dashes or by empty fields. You can then use the left-hand pair of numbers, two digits only, as a code number and the right-hand pair to count up or down.

The printing-in is automatically done for every frame, after you have pressed the key at the top next to the display.

By the way, you should always carry a ball-point pen, or something similar, in case you want to re-set anything in the display because the keys are difficult to press, even with long fingernails.

## Data Back 70

A much simpler back that is quite adequate for the ordinary family photographer. It provides data imprinting only. It gives you the choice between month/day/year, year/month/day, or the time of exposure.

## Program Back Super 70

This device, as its name suggests, goes one or more better than the Program Back 70. It was designed mainly for use in scientific and technical photography and it provides an unprecedented combination of computer control features

which are totally integrated in their operation with that of the Minolta 7000. It has a large dot-matrix LCD panel at the back that clearly displays exposure modes and other comprehensive information.

The following facilities are offered:

● Data imprinting: this is done along the right-hand edge of the film frame in the area normally masked by 35mm slide so it does not encroach on the picture area. Exposure data can be imprinted automatically and a variety of manually-set data, such as time, date, etc., as well.

● Exposure control: a total of seven exposure modes, including 3 programs, can be selected and then further adjusted to meet the subject or lighting requirements.

● Automatic Bracketing: up to 9 frames can be set to be exposed automatically with a choice of 1/4, 1/2, 1 or 2 stop differences between exposures.

● Intervalometer: a series of exposures at predetermined intervals can be set automatically with the starting time for the first interval delayed to one month. The starting time can be set to day/hour/minute along with other adjustments.

## Photos Without a Photographer

Let us now turn our attention to the function which we have mysteriously mentioned in the above section but have not yet described in detail.

You set it with the MODE-key and the indication ''INT.S'' has to flash in the display. If you change your mind and don't want to use this control function, then you simply let the ''INT.S'' carry on flashing, the Program Back 70 will return to the display of day and time. The control function allows you to tell the camera, from what time onwards, at what distance it should take ''n'' number of shots and (if necessary) over what period these shots should last. For all this bulky black boxes were needed a few years ago, but nowadays all you

need is a special back, only slightly thicker and a little heavier than the one which normally keeps your camera light-tight at the back.

From what time onwards.......... You tell the camera the starting time by entering the day, hour and minute by pressing the numerical keys. If you enter two dashes instead of the minutes all the other displays will disappear and the camera releases one second after pressing the INTERVAL-key.

.....at what distance ...... The time interval between two shots is programmed after keying SELECT and "INT.I" shows in the display. You again use the numerical keys to set the hours, minutes and seconds. The longest interval is 99 hours, 59 minutes and 59 seconds.

.....how many..... You can programme the number of the shots to be taken automatically after getting the indication "INT.F" on the display via the SELECT-key. Although it is possible to pre-select 99 shots, that would only make sense if the time interval is long enough to enable you to change the film.

The running time on the interval meter is started by depressing the INTERL-key; the release button has nothing to do with this.

The exposure control of the Minolta 7000 is maintained during normal interval meter use, you only have to choose whether the camera should take care of the correct exposure with the programme or a fixed aperture or a fixed shutter speed.

You can of course, if you prefer, set the aperture and shutter speed manually. In this mode another function of the Program Back 70 comes into play: it controls extremely long shutter speeds. For this the exposure control has to be set on "M" and speed has to be pre-selected as "bulb". You have to set the function INT.L on the back, and can then pre-select a speed by numerical keys, which can be just as long as the batteries allow.

You can combine this long exposure, the interval meter

unit and the data reference. To do this the time between two shots has to be longer than the exposure time plus the following film transport time (this is also valid for all the other exposure times which are set by the camera), and the data which are to show up on the film must be made visible in the display before pressing the INTERVAL-key. Even photos with flash are possible: the condenser of the relevant flash unit is charged before the shot, and the flash unit is switched off 15 minutes after the shutter release.

The Program Back takes control of the motor drive, because the DRIVE-selector has to be set to "S" and because the camera determines the exposure individually for every shot. If it is on "P", "A" or "S", you should cover the eyepiece with its cap, otherwise stray light might get into the camera and spoil the exposure reading.

# OTHER FACILITIES

.....and their use. We have made the acquaintance of the flash units and the Program Back, which are two important accessories from the Minolta 7000 programme, and both can be complemented with even more similarly effective pieces of equipment. Minolta can offer quite a bit more, as far as accessories are concerned, which could make your photographic life easier.

## For Better Sight

In order to best judge your subject in the viewfinder, Minolta offers, in addition to the built-in focusing screen, another three which you can fit yourself. If you like to take architectural photos or are interested in reproductions of old engravings, the Focusing Screen Type L is the right one for you. The grid lines allow you to focus on straight vertical and horizontal lines. Focusing Screen Type S, with the coordinate axes and graduations, is recommended if your special interest lies in the macro- or micro-range, or if your love belongs to the stars and telescopes. Finally, Focusing Screen Type PM is for sceptics who do not trust the AF system of the Minolta 7000, or for photographers who often get into situations where the automatic focusing could run into problems. The focusing screen PM has been provided with a microprism raster and split-image rangefinder.

We have already met the Angle Finder Vn. It is fixed to the eyepiece in the same way as the Viewfinder Magnifier Vn, which magnifies the central part of the viewfinder image to help you under very difficult focusing conditions. The eyesight correction lenses, which also fit onto the eyepiece, allow you to put your glasses away if your vision can be corrected within the range of + 3 diopters to − 4 diopters and you can get by without the intermediate values.

## The Camera on a Long Lead

You can release your Minolta by the remote control lead, as well as by the cordless remote control IR-IN, without pressing the release button or having to trouble the Program Back 70. This is particularly useful if you are interested in animal photography. You set up your camera in such a way that the animals will sooner or later have to pass into the field of view. You set the aperture by hand, so that the depth of field will be sufficient for successful pictures, and then observe the place of events from a distance and wait for the right moment. You have to switch off the AF because you cannot see from a distance whether the animal shows up in the acceptance field or not. You release by remote control at the right moment, without having to pull any wires through the trees, and the built-in motor winds the film on etc. As the observer, conscious of the animal's environment, you have avoided everything which might disturb the animal. If you don't know a lot about wild-life, then ask a forester or naturalist. Please, always remember if you wish to take such photographs that there are laws for the protection of certain species which also regulate photography.

## Filter or no Filter

There are filters and filters. One lot is there to improve the pictures as far as reproduction quality is concerned, and then there are the others which add effects to the picture. Whether you want to use any of the second group is a matter of taste. Certainly there are subjects which can bear to be dyed in one colour, and there are some which gain by the use of a star-effect filter, and for portraits the soft-focus filter, in principle another effect filter, is a simple means to a more atmospheric picture. A boring photo remains boring, even if a rainbow, glittering railings or bright colours attempt to disguise that fact. Just as every gimmick becomes boring if it

is used too often, so the most spectacular optical effect gets boring by constant use.

The filters of the first group are often more or less forced upon the photographer. The black-and-white photographer in particular needs the single-colour filters, they help to reproduce colours better as grey tones. Sometimes UV-filters (they should really be called UV-blocking filters, but that did not catch on) and sky-light filters are indispensable for the colour photographer because both of them reduce the UV component in the light and therefore prevent "blueing" of the picture.

Whereas effect filters have to be used with manual focusing (for instance, when a multiple prism is in use the Minolta 7000 would not know which picture goes with what), the yellow, green, orange and red filters which are offered by Minolta for black-and-white photographers, and the UV and sky-light filters (which can, of course, also be used by black-and-white fans) can be used with automatic focusing

Another important filter, the polarising filter, can only be used in a special (and unfortunately expensive) variant. The semi-reflecting mirror necessitates, as in other cameras with this component, a circular polarising filter. Normal light rays vibrate in all directions and the polarising filter allows only those to pass which enter along a certain plane. This helps one to obtain sharper colours, or clearer windows and water surfaces without reflections. As simple as it may sound, it is not simple at all. It is important that the sun is at a certain angle to the subject and that the filter disc is turned in the right direction (it is pivoted in its holder). You should allow enough time when practising with the polarising filter to observe the viewfinder very carefully, and use a tripod.

Because the polarising filter only selects certain light rays the others of course do not reach the film and so the exposure level will be different. But your Minolta 7000 measures the exposure through the lens, and hence also through the filter which is placed in front of it, so an error of exposure is unlikely. If you use your camera hand-held, you should pay

attention to the shutter speed (camera shake, wiping effect!), or to the aperture if you need a certain depth of field.

All the filters we have discussed so far are available in mounts, they are glass or plastic discs in a frame which can be screwed into the filter thread of the lens. As not all Minolta AF lenses have the same diameter you can purchase filters with the largest thread, even if they are more expensive and then use the larger filters with reducing rings on smaller diameter lenses: it is more difficult the other way round. However, this arrangement will give problems in fitting lens hoods and so you should work with the camera in the shade to prevent flare.

You can also purchase a film holder and cut out the filters from coloured film, but I would not really recommend them except as experiments.

# HUNT YOUR SUBJECTS FREELY

The most important rule for all photographers is to remember that the picture is made by the photographer, not the camera. That means that although the Minolta 7000 is a superb camera, and with all its accessories it is a tool which makes your photography as easy as possible without limiting your desires in any way, you are the one who has to spot the right subjects and it is up to you to put them into the picture.

A little note: ''A little of what you fancy does you good'' is another rule. Don't let other people spoil your enjoyment of the pictures you like! Your pictures are memories for you, they are an expression of your feelings at certain moments. If you can photograph your child when it is pleased about a new toy or is sad about a lost teddy bear, and if you have no time for picture composition, or just don't feel like it, then simply press the button. Ignore the people who talk to you about diagonal, foreground, middle and background! In ten or twenty years time, this picture will be a reason for joy and memory: ''Do you remember.....?''

But if you do have a little time, when you don't just take photographs in order to produce documents or to recapture who wore which fancy dress at the carnival party, but when you take photos because you enjoy photography, then you should care about the diagonal, the foreground, middle and background a little bit, and also whether the pictures are colourful or coloured.

## Many Colours Spoil The Broth

Black-and-white photographers can stop reading now. People who want to photograph in colour do not have to take their colour test, but they should think about one or two things. There are, for instance, colours which do not go together, they clash as one says. Blue and green is a pair; red and purple do not really want to harmonise. Nevertheless, you do not have to avoid these (and similar) colour pairs like

the plague. You can use this conflict for your picture and set the colours against each other, but do think about this effect very carefully so that you are not standing in front of the finished photo with the feeling that you dislike the whole thing.

On the other hand there are colours which complement and match each other; they are the complementary colours blue and yellow, blue-green and red, green and purple, but they do not necessarily have to be the 100% pure colours. A blue-green which has strong tendencies towards blue still goes with red.

Seeing colours is too complicated a matter to be explained here in detail. I only want to point out two more things which seem important to me.

Play with the colours, and remember that it is not only the colours which are in competition with one another but that the coloured areas of the picture also play an important part in the result. Large areas of a quiet colour can be offset by small quantities of an aggressive colour. You don't always have to harmonise the colours in every picture or just let a few colours be in competition with each other. If you photograph a flower bed, in which all sorts of flowers grow and bloom, then the multi-colours are the subject, there is no reason to deny these multi-colours. But not every picture needs several colours, one colour is quite enough for one picture. In this case one talks of monochrome colour creation.

# Get the Subject You Want!

If you want to create a subject of few colours out of a multi-coloured one, there is only one way: you isolate the less colourful part from the subject by using a telephoto with its narrow picture angle, or get closer with a shorter lens. That is not only useful for colours, it is never a mistake.

Before the shot you have decided upon a certain subject and not on something else. If you like the garden gnome in your neighbour's garden, then two-thirds of the rockery

*The motto for photography is: concentrate on the important things. That is why the animals fill the format as much as possible. Long focal lengths are imperative, because one very rarely gets close enough to an animal, and fast shutter speeds to avoid camera shake. Photos: Hans Joachim Dijkmann (above)Jochen Mentel (below).*

inclusive of the dustbin next to the garage should not be in that particular picture. Set the longest focal length on your zoom and then get so close that the little chap with his red pointed hat fills the finder completely, and only then do you release!

Naturally this rule is not valid unconditionally. For instance, if you want to photograph a portrait and your available focal length is just 50mm, you should not necessarily get very close to your victim. In this case try a portrait with the inclusion of the surroundings, the place of work or the flat of the person you want to depict, because that also says something about him.

## I Don't Know What to Photograph

Many photographers have bought their camera for the cupboard. There it remains only to see the light of day on birthdays, holidays and Christmas and, if it is lucky, a wedding might be another occasion when it will be taken out of its dungeon.

I presume that you have not bought your Minolta for this reason, but to take photographs. As long as you walk around with your eyes open you will never be without a subject.

Family: the members of your family are the first and most lucrative victims of your new or newly awakening photographic passion. Don't restrain yourself where snap-shots are concerned, but try your hand also at portraits, which you can illuminate using one or two flash units and some screens. But don't strain the patience of your loved ones excessively! If you stop in good time you can expect their co-operation next time. A model who is no longer interested in the pictures does not look half as nice as before.

Children: naturally they belong to the family, but small children particularly have to be photographed differently from adults. Children are snap-shot subjects. To catch them when they are involved in play, day-dreaming, or engrossed in the latest comic, you cannot set up the situations

beforehand. The world of little children is at a lower level than ours. Because of this kneel down, or lie on your stomach in order to get a picture of your little ones in their own world! Definitely, the Minolta 7000 is exactly the right camera for children's pictures. If they rush about in the garden, play football or frizbee, or make the drive unsafe with their roller skates, you are always ready to shoot because of the fast auto-focus.

Holidays: the most pleasant weeks of the year give us most of our subjects. Strange surroundings challenge discovery by the camera, and the Minolta AF zooms especially make sure that you are a match for the maximum number of subjects with the minimum amount of equipment. The stranger the area is for you, the better you should be prepared. Nothing is more aggravating than to discover that one has again and again passed by a picturesque subject only a short distance away because one didn't know it existed. Have a look at your travel guides, get to know the customs and traditions of your hosts so that you don't make a bad impression! Picture books give information about corners worth photographing, and so do picture postcards. That does not mean that you should simply copy everything you see, but that you know where to find something that is worth photographing.

Take along a few more films than you need during your holiday. If you buy them fresh they can be used a long time after the holiday, and films which have not been used have not been a waste of money. Put your film supply in a cool place at your holiday abode, don't always carry all your films around in the car and don't put them in the glove compartment! The heat could spoil the colours. The UV-blocking filter is doubly advisable for journeys to the sea because it not only removes excessive UV light but also protects the front element of the lens from spray which is often in the air near the sea. When travelling to the mountains a sky light filter gives protection from the high UV level, but it is only necessary for heights above 2000m because the complex lens construction with

the many elements is sufficient under normal conditions to protect against UV rays.

A blow brush for your lens should definitely be packed in your photographic bag, and perhaps a can of pressurised air to clean dust or sand from the camera body. If your holiday leads you to a place which you are unlikely to re-visit for a while, then the question of a second camera body becomes relevant. Two bodies, each provided with a different zoom (28-85mm and 70-210mm) make you independent of lens changes. Loaded with different films (black-and-white plus colour or ASA 1000 plus ASA 100) they are ready for quick reaction when different subjects are spotted, or for different light situations, without your having quickly to finish up the film you had started, or to take it out of the camera. Apart from that, no camera is immune from being knocked or dropped, and extreme environmental conditions (high temperatures, tropical humidity) could put it out of action. Then a second camera body is worth its money. (If you don't want to buy a second Minolta 7000 immediately then Minolta also produce very useful compact cameras which have got the advantage that they can easily be accommodated in a beach or hand-bag.)

Landscapes: of course landscape photography belongs to the holiday, but it can also be practised very well at home or on short excursions. Remember that telephoto lenses are landscape lenses too! The horizon is a very important line for landscape photos, and its position in the picture influences the picture content tremendously. The horizon placed low enhances the expanse of the sky, the horizon in the middle brings balance to the picture but often seems quite boring. The diagonal also comes into its own in landscape photography: diagonal lines show depth in the picture because they lead the eye from the foreground to the centre of the picture. Another point on the subject of the horizon: take your time to get the horizon horizontal in the finder, and thus in the picture! Especially for seascapes; it is not all that funny if the horizon lies at an angle and the water is ''running

out of the picture''.

Table-top: every now and then there are situations when one would rather remain in the house than look for subjects outside, but that is no reason at all to abstain from photography. Build little ships with newspaper and put the fleet on blue foil! You can take the most beautiful pictures with the macro setting of your zoom or with your macro-lens. There are no limits to your imagination (especially if children are taking part). There are enough toy figures from which one could become the title hero of a picture, and there is enough handicraft material from which whole landscapes can be developed.

# Minolta-AF-Lenses

| Lens | Elements/ Groups | Angle of View | Closest focusing distance | Min. Aperture | Filter-Dia. | Dimensions (Dia. x length) | Weight | Exceptional features: |
|---|---|---|---|---|---|---|---|---|
| AF 16mm f/2.8 Fisheye | 11/8 | 180° | 0.2m | f/22 | integral | 75 × 66.5mm | 400g | Built-in lens hood |
| AF 20mm f/2.8 | 10/9 | 94° | 0.25m | f/22 | 72mm | 77.5 × 53.5mm | 285g | Retro focusing |
| AF 24mm f/2.8 | 8/8 | 84° | 0.25m | f/22 | 55mm | 65.5 × 44mm | 215g | Retro focusing |
| AF 28mm f/2 | 9/9 | 75° | 0.3m | f/22 | 55mm | 66.5 × 49.5mm | 285g | Bayonet-mount lens hood |
| AF 28mm f/2.8 | 5/5 | 75° | 0.3m | f/22 | 49mm | 65.5 × 42.5mm | 185g | Built-in lens hood |
| AF 35mm f/1.4 | 10/8 | 63° | 0.3m | f/22 | 55mm | 65.5 × 76.0mm | 470g | Bayonet-mount lens hood |
| AF 35mm f/2 | 7/6 | 63° | 0.3m | f/22 | 55mm | 66.5 × 48.5mm | 240g | Bayonet-mount lens hood |
| AF 50mm f/1.4 | 7/6 | 47° | 0.45m | f/22 | 49mm | 65.5 × 38.5mm | 235g | Built-in lens hood |
| AF 50mm f/1.7 | 6/5 | 47° | 0.45m | f/22 | 49mm | 65.5 × 38.5mm | 185g | Built-in lens hood |
| AF 85mm f/1.4 | 7/6 | 28°30' | 0.85m | f/22 | 72mm | 78 × 71.5mm | 550g | Bayonet-mount lens hood |
| AF 100mm f/2 | 7/6 | 24° | 1.0m | f/32 | 55mm | 67 × 75.5mm | 480g | Bayonet-mount lens hood |
| AF 135mm f/2.8 | 7/5 | 18° | 1.0m | f/32 | 55mm | 65.5 × 83mm | 365g | Internal focusing, built-in lens hood |
| AF 200mm f/2.8 Apo | 8/7 | 12°30' | 1.5m | f/32 | 72mm | 86 × 134mm | 790g | Built-in lens hood |
| AF 300mm f/2.8 Apo | 11/9 | 8°10' | 2.5m | f/32 | integral | 128 × 238.5mm | 2480g | Internal focusing, built-in lens hood |
| AF 600mm f/4 Apo | 10/9 | 4°10' | 6m | f/32 | integral | 169 × 449mm | 5500g | Internal focusing, built-in lens hood |

# Minolta-AF-Lenses

## Important Technical Data

| Lens | Elements/ Groups | Angle of view | Closest focusing distance | Min. Aperture | Filter-Dia. | Dimensions (Dia. x length) | Weight | Exceptional features: |
|---|---|---|---|---|---|---|---|---|
| AF 24-50mm f/4 | 7/7 | 84°-47° | 0.35m | f/22 | 55mm | 69 × 60mm | 295g | Clip-on lens hood |
| AF 28-85mm f/3.5-4.5 | 13/10 | 75°-29° | 0.8m | f/22-32 | 55mm | 68.5 × 85.5mm | 490g | 1:4 macro* |
| AF 28-135mm f/4-4.5 | 16/13 | 75°-18° | 1.5m | f/22-27 | 72mm | 75 × 109mm | 750g | 1:4 macro* retro focusing |
| AF 35-70mm f/4 | 6/6 | 63°-34° | 1.0m | f/22 | 49mm | 68 × 52mm | 255g | 1:4 macro* |
| AF 35-105mm f/3.5-4.5 | 14/12 | 63°-23° | 1.5m | f/22-27 | 55mm | 68.5 × 87mm | 485g | 1:4 macro* |
| AF 70-210mm f/4 | 12/9 | 34°-12° | 1.1m | f/32 | 55mm | 72.5 × 152mm | 695g | 1:3.9 macro* |
| AF 75-300mm f/4.5-5.6 | 13/11 | 32°-8°10' | 1.5m | f/32-38 | 55mm | 72.5 × 163.5mm | 865g | 1:3.9 macro* |
| AF 80-200mm f2.8 Apo | 16/13 | 30°-12°30' | 1.8m | f/32 | 72mm | 87.5 × 166.5mm | 1300g | Anomalous dispersion glass |
| AF 100-200mm f/4.5 | 8/7 | 24°-12°30' | 1.9m | f/22 | 49mm | 69.5 × 94.5mm | 375g | Clip-on lens hood |
| AF 50mm f/2.8 Macro | 7/6 | 47° | 0.2m | f/32 | 55mm | 68.5 × 59.5mm | 310g | Double-floating system |
| AF 100mm f/2.8 Macro | 8/8 | 24° | 0.35m | f/32 | 55mm | 71 × 98.5mm | 520g | Double floating system |
| AF 1.4X Tele Converter Apo | 5/4 | | | | | 64 × 20mm | 175g | Magnification: 1:4X |
| AF 2X Tele Converter Apo | 6/5 | | | | | 64 × 43.5mm | 210g | Magnification: 2X |

* manual macro-focusing using LED focus signals

# INDEX

Acoustic warning signals 46
AEL key 45
Against-the-light 107
Angle finder 186
Angle of view 119
Aperture 77
Aperture priority 100
Aperture transfer lever 53
Artificial-light film 65
Auto-focus 23
Auto-focus contacts 25
Auto-focus/manual reversing switch 47
Auto-focus measuring field 30
Automatic programme mode 93
Available light 147

Black-and-white print film 59
Back release catch 49
Battery compartment 49, 114
Bellows 18

Camera shake 89, 95, 96
Children 193
Circle of confusion 19
Colour print film 61
Complementary colours 61, 191
Connection contacts 49
Contrast reproduction 17
Control functions 183
Control Grip 1000 172
Converging verticals 127
Correction factor 108

Data recording 179
Depth of field 19, 84, 101
Depth of field scale 57
Double ring zoom 57
DRIVE key 44
DX-indexing 115

Effect filters 187
Entrance pupil 78

Exposure 82
Exposure correction (flash) 172
Exposure metering 82
Exposure bracketing 112
Exposure value 81
Extension 121
Eyesight correction lenses 186

Family photos 193
Fill-in flash 167
Film 58
Film (calibration) 116
Film expiry date 67
Film pressure plate 53
Film speed 68
Film guide rails 53
Flash modes "Hi" and "Lo" 165
Flash range 165
Focal plane shutter 74
Focusing 18
Focusing screen 21, 186
Format, 35mm 161

Guide number 164

Holiday photos 194
Hot shoe 48

Illumination angle 171
Indirect flash 176
Infra-red film 65
Infra-red index 57, 67
Instant-return mirror 55
Instant slide film 67
Internal focusing 18
ISO 71
ISO key 44

Landscapes 195
Lens opening 77
Lens release key 47
Lens slide carrier 145
Lens speed 77
Light valve 81

Macro-photos 140
Main switch 46
Manual exposure 103
Microprism screen 22
Mirror 158
Mirror reflex principle 158
MODE key 44

Negatives 61
NiCad batteries 115

Panning 93
Pentaprism 161
Perspective 118
Plane of focus 19
Plus/minus key 44
Polarising filter 188
Portraits 150
Pre-flash 166
Print film 61
Program flash units 163
Program reset key 44
Program shift 94

Ready Flash indicator 166
18% reflectivity 83
Release button 46
Remote control 187
Remote control cable 146
Reproduction ratio 120
Reproduction stand 146
Reversal film 63
Rewind key 45
Rotating zoom 57

Separator lenses 25
Sharpness 17
Shutter 74
Shutter curtains 55
Shutter speed 75, 91
Shutter speed priority 102
Single picture mode 30
Sky-light filter 188
Slide film 63
Slow-speed synchronisation 169
Snap-shot setting 131
Split image indicator 22
Standard program 95
Stray light 125
Synchronisation time 164, 167, 170

Table-top photos 128, 196
Telephoto program 96
Test flash 166
Touch switch 46
Tripod bush 49
TTL flash metering 56, 165

UV-blocking filter 180

Vanishing point 118
Viewfinder 56
Viewfinder magnifier 186
Viewfinder prism 161

Wide angle program 95
Wiping effect 91

Zoom lenses 146